REMBRANDT
van Rijn

Publishing director: Paul ANDRÉ

Translation: Chanterelle Translations, London (Josephine Bacon, Victoria Quinn)
Production : Presse +

Printed by SAGER La Loupe (28) France
on behalf of Parkstone Press
ISBN 1 85995 164 3

REMBRANDT
van Rijn

PARKSTONE
AURORA

PARKSTONE PRESS, BOURNEMOUTH
AURORA EDITIONS , ST. PETERSBURG

Portrait of the poet Jeremiah de Decker. (Detail).

In the days when Dutch merchants traded in the Far East and the Antipodes, a miller named Harmen Gerritszoon van Rijn lived in Leyden. He had eyes only for the son who was born on 15 July, 1606 at the start of a century which promised so much and was so auspicious for men of destiny.

The child was later to be known simply as Rembrandt, his first Christian name. The young Rembrandt soon manifested the artistic skills, which his teachers discerned from his earliest years. After studying the humanities in his home town, the youth who had not yet passed his fourteenth birthday, enrolled at the University claiming to be an accomplished draughtsman. In 1621, Rembrandt became the pupil of Jacob van Swanenburgh, and completed his studies in the studio of Pieter

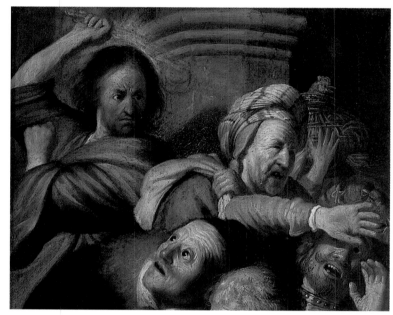

Christ Chasing the Money-changers from the Temple
(Detail).

Lastman, whose paintings of large frescoes of historical scenes instilled in him a love of precision, detail and sumptuous backgrounds of the type in which his master excelled. Rembrandt's official apprenticeship was relatively short. In 1625, the young Rembrandt set himself up in his own studio, ready to fulfil his own ambitions by trying his wings like other young men of his generation whom trade with India had precipitated into a different adventure, seeking to make their fortune. All Rembrandt had were his pencils with which he hoped to earn the comfortable living of which he dreamed and which his father, who died in 1630, had been lucky enough

to see emerge from the tip of the paintbrush. Whilst still studying under Lastman, Rembrandt painted many scenes from the Bible in which certain objects were illuminated with a conventional spirituality, which was often unusual but sincere from a pictorial point of view. He was inspired not so much by mysticism but the special mystery of the biblical story. Details such as the fabric of a headdress or the shadow of a column emerging from the background were highlighted to give emphasis.

The painter's own faith made him able to translate the saintliness of the figures to the canvas. Rembrandt was no longer sacrificing the subject-matter to the theatricality of the masters of his day, Caravaggio and Manfredi, whose work he found trivial. Rembrandt, at the age of twenty, was not the artistic heir of Michelangelo and the mannerists. When he lost himself in the excitement of painting, he was neither consciously a realist nor an expressionist. He merely listened to his inner voice and created an atmosphere of magic which he alone experienced but which he was able to convey in his paintings through the use of light and line. To understand this inner emotion is to enter into what a critic would later call Rembrandt's "tragic expression", which as early as 1626 was already perceptible in the most famous paintings now in the, Pushkin Museum in Moscow, such as *Christ Driving the Money-changers from the Temple*. The clear, bright colour scheme of this biblical

panel bears the hallmark of Pieter Lastman, yet despite a certain lack of harmony and unity, imperfect anatomy and doubtful perspective, the painting has an inner glow, a sort of premonition of the painter's genius and a strength of feeling which is greater than in his later works, when his technique had improved so extensively but his excitement and enthusiasm were no longer at their peak. Human emotions and the passions of the soul occupied pride of place in seventeenth-century philosophy. These were transmuted to canvas by painters, and was spoken of in the salons of the day. When the young Rembrandt depicted the wrath of the young Christ and the shocked money-changers shaken out of their routine, he was exploring the matters which preoccupied his contemporaries. The artist's intention was not to distance himself from philosophical debate, he was posing the problem in pictorial terms which contained in themselves his intellectual emancipation and the stamp of his unique artistic approach. Rembrandt's work showed none of the abstract and rather stilted "passions" of Lastman and his contemporaries. He patiently constructed his vision of the world and its inhabitants using a powerful natural and evocative touch. In later years, his spiritual nature and his artistic technique would produce an "aesthetic of emotion" without parallel. He perfectly controlled light and space in his paintings. His credo was to work from life, and he adhe-

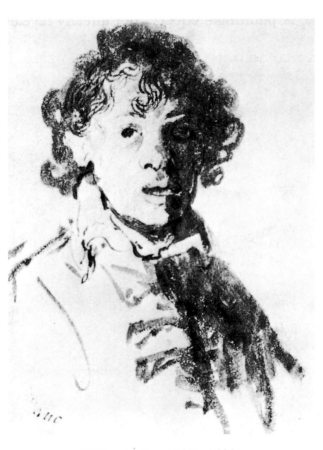

Self-portrait. c.1627 - 1628.
Pen and sepia wash. British Museum, London.

red to this throughout his life. It was at this same period that the young painter began to make prints and produced a series of striking little portraits of himself. These faces, sometimes grimacing sometimes wearing a sardonic or iron expression, are always very expressive. They provide a foretaste of the portraits he would paint from the 1630s onwards. There are no self-portraits in the Russian museums, whose collections form the main subject of this book, but the portraits in the Hermitage in St. Petersburg and the Pushkin Museum in Moscow, entitled *Portrait of an Old Man* and painted in 1631, are examples of his earliest commissions which made his reputation as well as being the foundations of his wealth. As soon as his fortunes improved, he began to climb the social ladder as his parents had so fervently hoped. He was only 22 years old when he took his first pupil into his studio. He had not yet mastered all the skills he needed from his teachers and his "imitations" of Lastman lacked assurance, but even if he was still "timid" in comparison with his later work, he never relented to convention. The infinite milling crowds of juxtaposed figures still eluded him, he was lost in a host of isolated subtleties; but he had already convinced several of his contemporaries that he was indeed skilled, and they were responsible for his gaining a reputation. Constantyn Huygens, secretary to prince Frederick Henry, a poet and traveller of refined tastes did not

hesitate to compare him to Jan Lievens, who exhibited unparalleled precociousness in the quality of his youthful work. On 20 June, 1631, an Antwerp art dealer, Hendrijk van Uylengurgh, signed a contract with the young Rembrandt, offering to set him up in his house in Amsterdam.

The *Portrait of an Old Man* shows great originality in the choice of size and other inherent aspects of the picture. A painting's effect depends on its size and the distance which separates it from the viewer. In this work, Rembrandt lends space to his composition. The painterly devices he uses are diverse and his brushstrokes, sometimes discreet, sometimes more noticeable, translate the expressiveness of the model, by revealing his feelings as well as his features and social standing. Rembrandt's experience of the "passions of the soul" breathes life into what would merely have been a two-dimensional portrait had it been painted by another artist of his generation. The *Anatomy Lesson by Dr Tulp*, painted in 1832, was commissioned by the Amsterdam Guild of Surgeons, as a result of the *Portrait*, whose owner had quickly spread his enthusiasm for the painter.

Rembrandt was young and proud and hardly ever left the studio. The *Self-portrait in a Cap* in the Cassel Museum, painted in 1634, shows him very much in command of himself, strong and confident of his future. He knew how to

vary his compositions depending on the model, yet at the same time he was constantly satisfying the demands of a permanent apprenticeship which enabled him to improve his technique and methods with each canvas he painted. This can be seen in *Young Man in a Lace Collar*, now in the Hermitage Museum in St. Petersburg. This portrait, which was painted in 1634, meets the standards of the time, but already reveals a ghostly and unconventional understanding in the facial expression, in which the relaxed manner of the sitter emphasises his pleasant smile and the lightness of his features. The chiaroscuro gives the whole picture a sense of reality of tone which may well have flattered the young dandy who was concerned to look well turned-out, and one can feel the strength of the life spark which the artist captured for posterity. It was during this decade that Rembrandt firmly established his reputation. While continuing to produce the same kind of portraits as his contemporaries, he constantly produced illustrations for contemporary writings and mythology through a succession of paintings in which his imagination was allowed a free rein. While at the height of his technical skills, the painter decided to place his models in a context. They were often submerged in scenery full of historical allusions, appearing in costume or surrounded by carefully-worked symbols. Despite this fancy

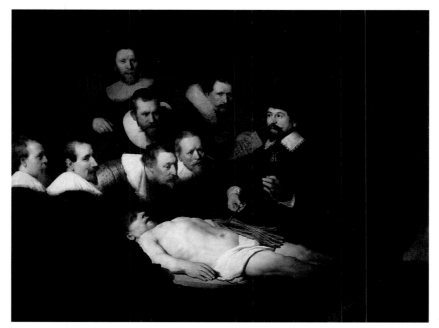

The Anatomy Lesson by Dr. Tulp. 1632.
Mauritshuis, The Hague, Netherlands.

Portrait of an old woman. Visage. (x-ray plate).
Pushkin Museum of Fine Arts, Moscow.

Flora. Face. (x-ray Plate).
Hermitage Museum, St. Petersburg.

dress, the men and women portrayed revealed their personalities without ever sacrificing the originality of the genre. Rembrandt married Saskia van Uylenburgh on 10 July, 1634 and she posed for him in the first year of their marriage as did a young boy whose identity is now known. Both these portraits are in the Hermitage Museum in St. Petersburg. They exemplify a tendency in art which Rembrandt was happy to adopt, because it enabled him to expand his horizons while incorporating his knowledge and experience gained over the past twelve years.

During this era he also produced a few grisaille paintings as curiosities. The *Adoration of the Magi*, painted in 1632, is one of these less happy experiments, much practised by his contemporaries, but extremely rare in Rembrandt's work. He used one or two of

these experimental works as originals from which to make etchings, but these were limited to a few test-pieces which he found sufficiently unsatisfactory to cause him to abandon this line of endeavour.

There are few sketches by Rembrandt, apart from those which have now ben revealed by taking x-rays of a few of his paintings. These do not enable us to establish the exact genesis of his paintings, but by comparing them with the grisailles he has left us, one can get a fair idea of the manner in which he painted. The only colours on his palette would be white, ochre and lamp black, and he would cover the canvas with large patches of transparent sepia which almost always remained intact where shade was called for in the painting; then the lit parts of the faces were modelled by a trace of white which would be worked in the shaded

areas in long black or brown strokes. This is how the *Adoration of the Magi* was composed, though there were numerous retouchings, repaintings and constant modifications until the work was deemed to be completed. Through this analysis, it can be seen that ten years later, in *The Money-changers in the Temple*, the artist had lost nothing of his fiery temperament, but on the other hand, being less subject to getting carried away, he was in fuller control of the subject-matter. It was during these years that he created a series of paintings on biblical themes, one of which, *The Incredulity of St. Thomas* (1634) is in Moscow and three others – *The Descent from the Cross* (1634), *Abraham's Sacrifice* (1635) and *The Parable of the Labourers in the Vineyard* (1637) – are in St. Petersburg.

Rembrandt's imagination dictated the settings, which were always very theatrical and particularly "lively". Life, as depicted by Rembrandt, was translated by a very powerful mimicry and his desire to confront history and those who made it, and to "dramatise" these events in order to render them "truer" and more convincing. Under his brush, the theology of the event he is depicting becomes "humanised" by the setting, the dress and the light. In fact the artist's approach was one which the Reformation had created in artistic interpretation. The Protestants took Holy Writ as a subject for historical and philosophical study, and considered biblical texts as a genuine source of historical material, rather than a series of parables and images. Almost

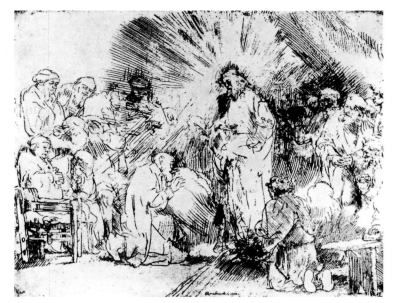

The Incredulity of St. Thomas. 1650.
Etching.

from the outset, a strong tendency appeared in Protestant art to reproduce not merely the symbolic, but the literal meaning of biblical stories too. Rembrandt was very taken with this intellectual approach and from the late 1620s, depicted several important scenes in order to demythologise them. This prosaic interpretation of the Bible was not unique to Rembrandt, but more than any other artist, he was able to give them an incomparable internal strength.

Rembrandt's artistic vision also betrays close ties to the Dutch tradition of painting. Yet he strongly dissociated himself from the concept of History behind the host of paintings created at the time which he considered to be impersonal and lacking in the "imagination" which, in his opinion, would have brought them to life. He thus chose to represent a very "oriental" world as the thread linking his "scenes". Yet this decade is characterised equally by a change in his method of painting, which an analysis of his *Danaë*, of which the first version was painted in 1636, but which was completely reworked ten years later, makes it easier to understand. This painting clearly exposes the artist's interior world at a moment when it was fast evolving and reveals the "spirit" of his ambitions. Between the two dates, Rembrandt's art had undergone radical changes. *Danaë*, when studied in its two different versions, shows Rembrandt's desire, after his enthusiastic and prolific youth, to radically rework his painting, in the light of his later painterly vision. This is no

slow evolution of his art, as was the case with *The Night Watch*, completed in 1642 after several years' work; this is a radical revision of a painting which had been completed many years previously, transforming it into a completely new work, produced using a different technique designed with a new sensitivity. *Danaë* thus summarises the two stages of his artistic life without the result being hybrid and denatured. During the 1640s, Rembrandt painted many portrait. The diversity of his approach and the variety of brushstrokes gave them considerable importance. The simplicity and modesty of the portraiture caused great admiration and is indicative of the painter's talent and maturity. The *Portrait of Baartjen Doomer* (1640) and the *Portrait of an Old Woman* (1650) – exhibited respectively at the Hermitage Museum in St. Petersburg and the Fine Arts Museum in Moscow – mark the beginning of the end of the artist's studies in this field. This was an unhappy period in the artist's private life. In 1639, while his contemporaries were celebrating his genius, Rembrandt and his wife moved to the house he had just bought for thirteen thousand florins in the Jodenbreestraat, in Amsterdam. It was an elegant bourgeois dwelling on three floors, embellished with sculptures, and which

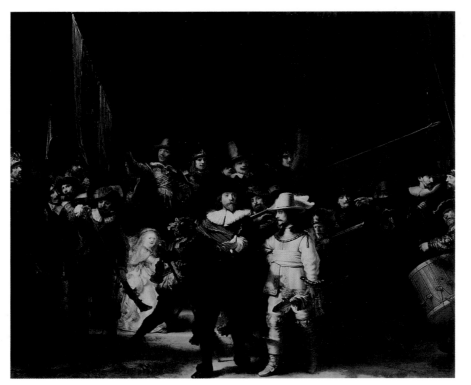

The Night Watch, 1642.
Rijksmuseum, Amsterdam.

inspired great pride in him until it precipitated him into financial difficulties. His lifestyle was important to him, but he was also one of the most handsomely rewarded painters in Holland. He could easily command one hundred florins for a portrait, while the paintings of most of his contemporaries would be lucky to get between twelve and seventy-five florins. Fortune smiled on him until the death of his mother in 1640, and Saskia's demise two years later put an end to his joie de vivre. His son, Titus, born in 1641, would be his comfort and support until he died in 1668, six months before the birth of his daughter. During this period, Holland became very wealthy as a result of its great maritime adventures, and was now becoming settled and complacent, confident in its future, and started to seek refuge in the conformity of its Golden Age and began to reject some of the great artists who had previously been highly acclaimed. This was the fate of Franz Hals, who was now supplanted by painters with a greater aristocratic refinement, such as Gerard Dou, Ferdinand Bol and Govaert Flinck, all of whom had studied under Rembrandt. But the master had not had his final say, and although his fame suffered from this rigid attitude, he nevertheless continued to paint and sell his canvases. It was during

10

this period that he concentrated on the Jewish community of Amsterdam, whom he sketched with the sympathy of a friend and confidant. This was also the period in which Titus, under Rembrandt's tender gaze, became successively Christ, Tobias, Daniel and the young Joseph. The paintings in the Russian museums perfectly illustrate the tone which the artist gave his portraits during this decade. Baartjen Maertens Doomer, whom he portrayed in 1640, was not in high society, she was the wife of a craftsman who had close contacts in artistic circles; Rembrandt was immune to the conventions and he created this portrait with complete freedom, following his artistic impulses. He reproduces the lively expression of the lady whose cheerfulness emerges in every stroke. The whole depiction is based on the drawing which Rembrandt created as an integral part of the painting, following the expression to become more and more precise as the painting took shape. Painting his sitters as they really were, he imbued the portraits with their whole personality in order the better to bring them to life.

In seeking to bring out the "mobility" of the sitters, Rembrandt managed to obtain a likeness such as no one had ever been able to achieve hitherto. For more than ten years this method led to the apotheosis of Rembrandt's work. The *Portrait of an Old Woman,* painted in 1650, was in the same vein. With complete mastery of his art, he gradually eradicated the dual perception of the world which had prevailed in his work hitherto, and which was typical of the previous decade, which consisted in distinguishing commissioned work from his personal vision of art, separating historical panels from the portraits. These works would now be combined in a single vision of the world which now bore a single signature – that of Rembrandt.

The large red cloth in *The Old Woman,* which was by no means typical of the time but which was favoured by the Master, as well as old-fashioned "Burgundian" dress give the feeling that this was not so much a commissioned painting but rather a work of the artist's own inspiration. Yet the method used and the strict "objectivity" of the portrait are reminders that at the time Rembrandt had gained complete artistic freedom which would never be diminished. "Man and his state of mind" would become one of his major interests, and the older he became, the more he reflected upon the internal solitude of those whose portraits he painted, in his eyes the only vector of a meticulous transcription of the

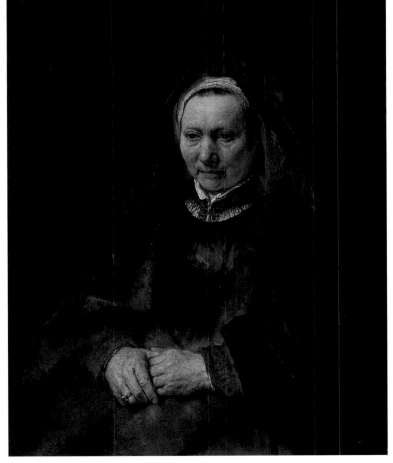

Portrait of an Old Woman, 1650.
Pushkin Museum of Fine Arts, Moscow.

personality, which through experience and observation he was able to turn into flesh and blood. By fixing a moment of life on the canvas without ever stopping it in its course, he was able to portray the richness hidden within his models and to make a look, an expression betray their most intimate thoughts and the secret of their existence. Even those portraits which were his personal inspiration, for which Rembrandt often used the same models over and over, express the diverse nature of the "soul" and the profound nature of the human beings whom he placed within his genre scenes. That is how he "unmasked" his older brother, Adriaen van Rijn, whose features were used as a medium for characterisation in the various portraits of old men painted in the 1650s. These paintings are of great interest to those wishing to study the "Rembrandt method". The two portraits of an Old Woman painted in 1654, in the Hermitage Museum in St. Petersburg and the Pushkin Museum in Moscow, used the same model and respond to the same criteria as regards their creation. The technique adopted, which is unique to the artist, is very varied as regards the manner of applying the colours around the eyes and in the shaded parts of the face. It is a series of brushstrokes and semi-transparent patches of colour whose outlines

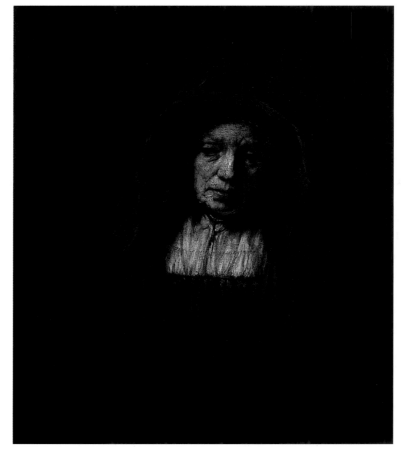

Portrait of an Old Woman, 1654.
Pushkin Museum of Fine Arts, Moscow.

are blurred. There are areas which are brightly lit, and a heavy layer of impasto consisting of short and long strokes of different colours. This method enables the artist to pass from light to dark, a technique he mastered better than anyone. Finally, over and above the intelligent amalgam of colours, the position occupied by these brushstrokes in space and the direction of the paintbrush on the canvas contribute to the three-dimensional effect so often admired in Rembrandt's work.

There are numerous variations on these techniques among a number of Dutch artists, but theirs never matches the sureness with which Rembrandt used them.

In Rembrandt, the human face was always associated with the life which had shaped it. Furthermore, each portrait reflected a particular attitude in which the enigmas of existence could be read. The elderly people he painted in 1654 had a particularly tragic view of the world. They knew life to be full of pain, injustice and cruelty. This world view was familiar to them, however, and did not cause them to rebel against it within themselves. Their loneliness was manifest, but it did not prevent the artist from discovering the complex ties which bound them to life, which he revealed in their wrinkled faces. Rembrandt's old people are the incarnation of human wisdom. A exceptional

spiritual value places these individuals above the daily routine and confers a tragic grandeur upon them and converts their philosophy into an absolute truth, one worthy of the whole la nation. These portraits mark the apogee of seventeenth-century art in Europe, and have no direct descendants. It was not until two centuries later that artists would once again tackle the ambiguous relationship between man and his soul; but in the works of the romantic painters, the common people were not considered to have the wisdom or the grandeur of the figures painted by Rembrandt His genius

Portrait of an Old Woman Face (x-ray plate). Hermitage Museum, St. Petersburg.

this has not always contributed to the posthumous reputation of the artists. Seeking to please rather than to "bring out the expression", many of Rembrandt's pupils abandoned the style which best suited them, large brushstrokes and thick paint for a lighter touch, one which was smooth and too frequently inconsequential. This was a style which many used, born of financial success the growth of the middle classes and changes in fashion. Even though the most competent painters translated this shift of opinion, which was already being served by such mas-

was to place them in a setting which would best express their personalities, so that in their individual expression they would lose any disadvantage conferred by their social status. Rembrandt transferred his own feelings to his model. Having found in a human being what he shared with them in terms of their view of the world and their state of mind, he painted each of the numerous portraits which made him famous like a fresco reflecting the image of his century. Less than a genre, Rembrandt's portrait is scrap of truth torn from mankind.

Despite the importance of landscape painting and genre scenes, the Dutch painters continued to draw their inspiration for subject-matter from portraiture. Since such portraits were a source of both honour and profit, many artists were unable to resist flattering the images commissioned by their patrons and

ters as van Dyck, Rembrandt did not become one of them and continued to defy the artistic currents and his accumulating financial woes working without making the slightest concession to fashion. In the late 1640s, when Hendrickje Stoffels, became his model and went to live with him in the house on Jodenbreestraat, he continued to pursue his own aesthetic style, alternating commissioned portraits with those of his own inspiration, and with historical scenes in which he adroitly combined his models with his own "visions" of the world.

His artistic language had attained an unequalled virtuosity. Sometimes resorting to very simple methods, sometimes using an ingenious and complex mixture of brushstrokes (thick, semi-transparent or transparent), he managed to create "unities of the soul" in

13

which each element is inseparable from the whole. There is no splash of colour, no brushstroke which is not important in itself, all the elements of the artistic language have acquired a psychological and spiritual basis which only exists to the extent that they are imbued with it. That is why it is practically impossible to extract and isolate the image from its psychology and to find adequate terminology with which to define it. It is an element which is inherent in painting.

In the second half of the 17th century, Holland was to experience a series of upheavals, such as the war against England in 1652. This was the start of a difficult period. At this time, while the Dutch were fearful of their future, Rembrandt, like a magician who remains untouched by current events, continued to present the public with images of a different reality. Deaf to the agitation of the Dutch populace, he lived in a world which he had redrawn to his own specifications, consisting of reds, browns and blacks, whites and yellows mixed in subtle touches, melting together on the canvas beneath his magical brushes. He seemed to care only about his combinations of colour and light with which he played so skillfully in the midst of the shadows. Rembrandt was so captivated by his art, it became almost an obsession, and he could only perceive the world through his paintings. Pursuing his dream, brushes in hand, he continued to create portraits in oils and to make etchings of others, yet

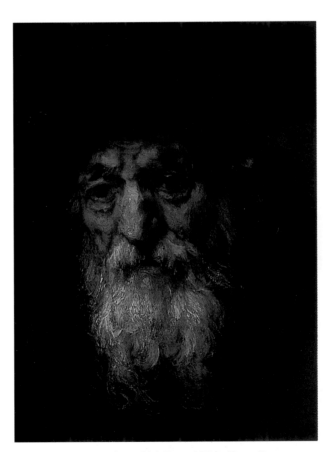

Portrait of an Old Jew. 1654 (Detail). Hermitage Museum, St. Petersburg.

without abandoning the scenes from the Bible in which people and the world were reflected. Life continued around him but he appeared to remain unaware of it. He embarked upon a tumultuous course which led him into the greatest financial difficulties. The artist had been showered with honours and the love of Hendrickje, the patient force behind his illuminations, had hidden the serious consequences and had detached him from the conventional and pompous society with which he refused to compromise. In July, 1656, heavily in debt, Rembrandt found himself unable to meet his commitments. His income no longer covered his expenditure and he was forced to leave his lovely home in Amsterdam, abandoning it to the bailiffs. His magnificent art collection, which included many contemporary works, as well as those by Raphael, Giorgione and van Eyck, antique statues and Chinese and Japanese works of art, suits of armour, minerals and even a lion skin, was auctioned off. Yet he was not driven into bankruptcy.. Hendrickje and her son Titus turned themselves into a firm of art dealers and made the Master into their employee, so that the income from the sale of his pictures would not be swallowed up in reimbursements to his creditors.

Rembrandt's new home in the working-class Rosengracht district, was by no means unpleasant. He continued to work ceaselessly despite adversity, drawing inspiration from the working people though still retaining the

friendship, and even the admiration, of the great and the good. In 1667, Cosimo de Medici, the future Grand Duke of Tuscany, visited him in his studio in order to purchase one of the two *Self-portraits* which are now in the Uffizi Gallery. in Florence.

While measuring the inanity of human pretentions, Rembrandt was able to escape the self-pity of deep depression because even in this time of crisis, he still had his painting left. His work lost more constraints and became more ethereal. The 1650s produced more masterpieces in the painter's catalogue, some of which are in the Russian museums. The *Young Woman Trying on Earrings* dates from 1657. It a painting of a rather rare type in which a young beauty admires herself in a mirror. Although this is an allegorical image of vanity which was very much of the period, it cannot rival *The Return of the Prodigal Son*, generally considered to be the perfect illustration of Rembrandt's mature genius. The latter painting gives a good idea of the artist's own philosophy of life, and his attitude towards existence, which he regarded as artificial and superfluous.

The historical paintings of the last decade of his life clearly illustrate the essence of Rembrandt's art, the subjects which interested him the most and what we was able to offer in terms of aesthetics. *Haman, Esther and Ahasuerus*, painted in 1660, is indisputably one of the most peaceful paintings of the Master, as well as one of the most taciturn. Esther

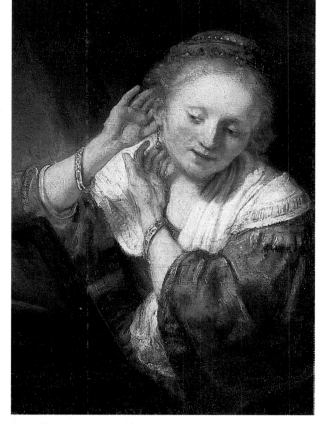

Young Woman Trying on Earrings (Detail). 1657. Hermitage Museum, St. Petersburg.

has just made her accusation to the king who sinks into a profound meditation, refusing to believe the truth revealed to him. The lack of any outside action and the apparent isolation of the figures from each other enables the artist to reveal the character of each of them, the relationship between them and the fate that awaits them. Man face-to-face with himself: this was Rembrandt's major preoccupation when he painted a portrait. It was these same problems, seen from another era, transposed to the biblical world, which would continue to preoccupy him until he breathed his last.

Each of the figures in *David and Uriah* (1665) painted in the foreground against a dark background, seems to be searching his own soul; although there is no explicit indication which would interpret the scene exactly, the relationship between the protagonists clearly illustrates the painter's intentions. An oriental dignitary oriental accepts his loss and accepts his fate with self-denial and a monarch who has just ordered his arrest and execution, yet whose face expresses sadness rather than his wrath. An old man and several prophets are witnesses to the scene.

Yet it is in the *Return of the Prodigal Son* painted in 1668-1669, that Rembrandt attained the perfection of his art. It was a historical quest which had reached its conclusion, the Gospel parable made flesh and for the artist perhaps, who was over sixty when he painted it, though in a perpetual quest for the truth, a response to the

perplexing question of the supreme meaning of life. The reuniting of father and son were a possible summing up of their earthly existence and all the sufferings experienced during their long separation. Man is shaped by his own past. The moment of the actual meeting is so emotional that legitimate joy has given way to something resembling sadness, but which is probably more like a serene melancholy, regret for the lost years.

Although very different as to the dates when they were painted, the scale of the figures, the size of the canvas, the composition and even the technique give these three works perfect spiritual unity through the emotions they portray. It has been said that the heroes in Rembrandt's later works exist "outside time and space". This is only true if one considers that they exist outside a space filled with everyday objects and that they live outside time filled with everyday routine. Their lives are governed by a clock which does not apply here on earth, it is a different rhythm of time and space. There had been a period when the artist had delighted in creating an imaginary and flamboyant Orient. Henceforward this type of background seemed to him to be superfluous and he contented himself with dressing his figures in a few exotic fripperies. All other indications of place and time are absent or merely hinted at, The Roman portico in the *Prodigal Son* is barely discernible, the table, the ewer, the dish of apples and the cup in Haman's hand are the only indications of the feast held by Esther and Ahasuerus. In the *Return of the Prodigal Son*, the artist went as far as leaving out the characters mentioned in the Bible and who had been part of the pictorial tradition of the parable.

In Rembrandt's works created in the 1630s, the importance of the action was determined by the magnificent backgrounds. Those of the 1640s were characterised by their de pictions of everyday scenes. Henceforward, as his final works show, everything concentrated on the inner worlds of the figures whose intensity throws back into the shade anything that appears to be subordinate. The painter now concentrates completely on the soul of his models and has deep compassion for them. They are looking inwards at themselves, and all the attention is focused upon them. Everything that is secondary and fortuitous is eliminated in order to show what is in their minds.

Rembrandts figures are now either immersed in the limelight or almost invisibly submerged in shadows, depending on the painter's whim. Yet wherever they are placed in the painting, they remain isolated from the world and from

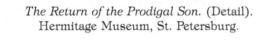

The Return of the Prodigal Son. (Detail).
Hermitage Museum, St. Petersburg.

16

other human beings, as if strangers to the course of life. One sometimes has the impression that they cannot see, despite the ties which bind them to their common fate. Rembrandt's figures passively accept the grand designs which are their inexorable fate but they are also confronted with their own lives. Even Esther, who by her actions directed the course of events in order to deliver her people from a hideous fate, is eventually merely an instrument of God's will and that of Mordecai. The beautiful gentle queen performs what is written for all eternity with a dignity that is full of modesty. In Rembrandt's later work, human life is attached to the concept of destiny which while being inherent in man, escapes him completely. His destiny can be followed with dignity, the figures seem to say to the Old Master, one may rebel internally but it is not possible to fight it. Rembrandt's sombre genius understood the sad, almost unconscious undertone of this impassioned impetus. There is an echo here of everything that would be most surprising in the work of Byron. "Before me there is the head of a man who with one clean line can only be half-seen", wrote the young poet Lermontov two hundred years later when viewing a Rembrandt portrait. "All around, there are only shadows. His haughty expression is both burning and yet at the same time full of anguish and doubt. Perhaps you have painted it from nature, and that this effigy is far from being ideal! Perhaps you have depicted yourself as you were during

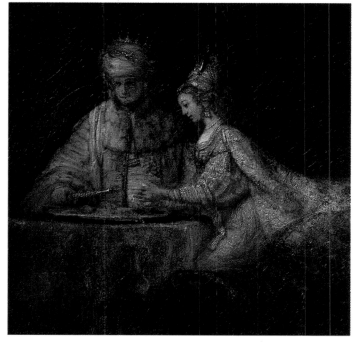

Haman, Esther and Ahasuerus. 1660. (Detail).
Pushkin Museum of Fine Arts, Moscow.

your years of suffering? Yet a cold look could never penetrate this great mystery and this extraordinary work will remain a bitter reproach to heartless people". The character of Rembrandt's figures are deaf to this vision of man which the Romantic period would celebrate with such misguided enthusiasm. It is probably *Titus van Rijn in a Monk's Habit* which Lermontov, then only 16 years old, described in his poem about a Rembrandt painting. This work was then in the collection of the Counts Stroganov in St. Petersburg and the young man was suddenly inspired and saw the image of the heroes who populated his own world and his imagination. In his eyes, this painting is an incarnation of "the great mystery of art" and the even more inaccessible mystery of his own destiny. The poet describes the "sombre genius" of the painter and identifies with the passion and sufferings of the artist and his loneliness in the world.

The artist's philosophy, his subjective vision of the world are those of a convinced sceptic. The tragedy inherent in Rembrandt's last paintings is generally explained by the adversity he had suffered, and the painful solitude he had experienced as an artist. Saskia's death and the subsequent death of Titus in 1668 certainly affected him deeply since he was very sensitive and all he that he felt in his heart is reflected in the faces of his figures. The economic crisis in the Low Countries, as well as his own financial difficulties also decisively affected his

work. Yet it was not so much the outside influences as his own innermost nature which he was painting in the shadow and light of his good and bad days. In Rembrandt, even happiness had it own colour but it was the colour of melancholy. Even the two women who had done something to brighten his son existence after Saskia's death – Hendrickje Stoffels from 1649 until her death in 1663, then Magdalen van Loo after 1668 – did nothing to change his vision of mankind. There is evidence of it in his early work, and his later works only reinforced his attitude.

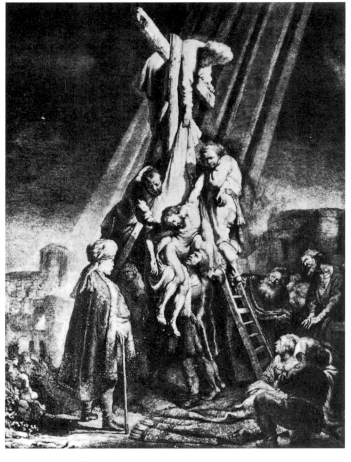

The Descent from the Cross, 1633.
Etching.

measure the place he occupies in our spiritual heritage Tsar Peter the Great brought the first Rembrandt's to Russia. He first had the idea in 1697 during his first trip abroad. Yuri Kologrivov visited The Hague on 1715 and returned with 43 paintings to be used to adorn the Palace of Montplaisir at Peterhof, which was then still under construction. But his task was not complete, since he then travelled successively to Antwerp and Brussels, finally acquiring 117 other paintings by Amsterdam's Old Master. At the same

Rembrandt Harmen Gerritszoon van Rijn died on 4 October, 1669, leaving more than six hundred paintings and an impressive series of etchings. There were portraits, religious subjects, landscapes and genre scenes. The paintings which can be seen in the Russian museums give a clear idea of his art because the collection summarises his life's work and the manner in which it evolved. The portraits show the brilliance of his art and the variety of subject-matter in his historic paintings show the diversity of approach. Rembrandt's work, which is so strongly personal, occupies a unique place not only in painting but in the whole of European culture. When Rembrandt is compared with his predecessors or even with his successors, one can see the total originality of his creativity and can precisely

time, the ambassador Kuranin and commercial attaché Soloviov were entrusted with a similar mission. The result was that in the following year, 150 paintings entered the Russian collections. This was a period during which Rembrandt's paintings were considered to be either "heretical" or old-fashioned. They rarely came up for public auction and when they did so they fetched derisory sums.

The first paintings were hung in the Hermitage in 1764, less than 100 years after the artist's death. They represented a lot of 225 paintings, consigned by a merchant from Berlin as part-payment of a debt which he owed to the Imperial treasury. Prince Golytsin, the charge d'affaires in Paris, and a friend of Diderot and Falconet,also played a very active part in the adornment of the new art gallery. Two major

works now in the Hermitage owe their presence to his endeavours. These are *Portrait of An Old Woman in Spectacles* and *The Return of the Prodigal Son*. In St. Petersburg, Rembrandt continued to enjoy a high reputation. The Imperial Russian court showed great enthusiasm for the work of the Dutch Master who had no equal in western Europe where his works continued to be regarded at best with indifference, at worst with disdain. For instance, in 1772 Falconet wrote as follows to Catherine II: "I received notice from France that there is a perfectly beautiful Rembrandt painting available which makes a pair with the Prodigal Son. If it really is as good as that, then this item would be worthy of your gallery. If your Imperial Majesty should command me to do so, I shall write to one of our best artists to go and see the painting and to judge whether it is as good as it is reported to be; because I am very wary of giving this task to any others. The subject is Mordecai at the feet of Esther and Ahasuerus. The price is three thousand six hundred pounds". Shortly thereafter, Catherine replied to Falconnet that if the painting was as good as her *Prodigal Son* she would be happy to pay that price. In fact, the sale never proceeded, although the painting remained in Paris for 15 years without finding a purchaser. Today it adorns the walls of the Bucharest Museum. In 1769, after several years of legal battles, the collection of Count Heinrich Brühl, former minister of Augustus III of Saxony, was acquired by the Hermitage. Among the treasures amassed by the count and his secretary, who was the curator of the

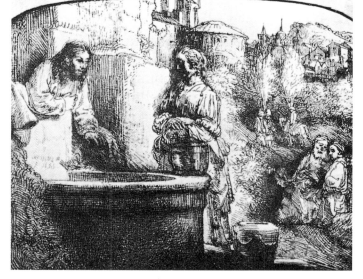

Christ and the Samaritan Woman, 1658. Etching.

Print Room of Dresden and an informed art critic, there were four Rembrandts, *Portrait of an Old Man* and *Portrait of an Old Man in Red* now in St. Petersburg, as well as *Portrait of Adriaen van Rijn* and *Portrait of an Old Woman* which are now in the Pushkin Museum in Moscow. *David and Uriah, Flora, Danaë* and *The Sacrifice of Abraham* are among numerous acquisitions made throughout the 18th century, after the deaths of many great foreign collectors.

In the next century, Rembrandt was rediscovered by the Romantic movement and emerged from the obscurity to which he had so long been consigned, both in his own country and elsewhere, with the notable exception of Russia which had so cleverly profited thereby to enrich its own collection. When the critic Herzen discovered in the world of Shakespeare and Rembrandt "a world in which life is reproduced in all its depth and with every gradation of light and shade", he was merely stating the obvious to all. In artistic and scientific circles, the Master of Amsterdam was no longer considered to be a heretic seeking to break the academic rules, but as one of the greatest artists of his time. His paintings, so long considered the work of an artistic maverick were now admired for the logic of their painterly language.

Today, the Russian painter Kramskoy considers Rembrandt's work to be as great a milestone in the history of painting as is Greek statuary in the history of sculpture. Rembrandt's work was jealously admired by 19th-century painters who tried to use it as inspiration, copying

his ideas and techniques as best they could, since his sentiments were much in keeping with the time. Although Rembrandt had held a fascination for Russian artists for even longer than this, the study of his work was only in its infancy. The scope and quality of the Russian collection contributed much to promoting Rembrandt's work and the constant policy of acquisitions built on an increasing familiarity with his work which never caused enthusiasm for it to diminish. In 1814, Alexander I bought the Empress Josephine's collection, Acquisitions continued even after the October Revolution. The Hermitage was first opened to the public in 1852, Thus Lermontov's enthusiasm could be appreciated by the people who now had the chance to fully understand the allusions of the poem.

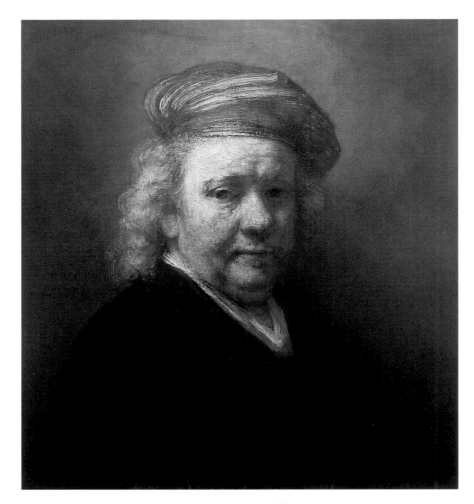

Self-portrait. 1669.
Mauritshuis, The Hague.

ANNOTATED

CATALOGUE

1. CHRIST DRIVING THE MONEY–CHANGERS FROM THE TEMPLE

Oil on wood (oak); reinforced, 43 x 33 cm.
Monogram and date on the pillar
in the centre at the top: RF. 1626
Moscow, Pushkin Museum.
Inv. N° 1900. Acquired in 1924.

It was not until 1915 that this work from the artist's youth – which was until then little known – was officially attributed to Rembrandt. Subsequently, certain critics suggested that it might be a fake, but the matter was definitively settled after the canvas' restoration in 1930: the analysis of the pictorial structure dismissed any doubts, along with the discovery of the artist's monogram which had been hidden until then by a thick coating of varnish. The identity of the artist was again questioned in the 1960s, when further specialists judged that the flaws apparent in the painting indicated that it was the work of a student, or the exercise of an unknown artist. In 1970, the issue was finally decided after the painting was examined under ultraviolet rays, confirming that it was indeed an original canvas on which the artist, still in the process of mastering his skill, had proceeded to repaint certain parts at different times. This led to restorations and smudges in the varnish, notably on the left forearm of the figure of Christ, in the upper left-hand corner of the painting, to the left of the money-changer's profile located at the bottom of the scene, and along the border at the bottom of the canvas. A number of scratchings in the fresh paint are also apparent – a process often used by the young Rembrandt – but were also carried out on dry paint. All these amendments are three centuries old, and the painting is now attributed with absolute certainty to the young artist from Leyden.

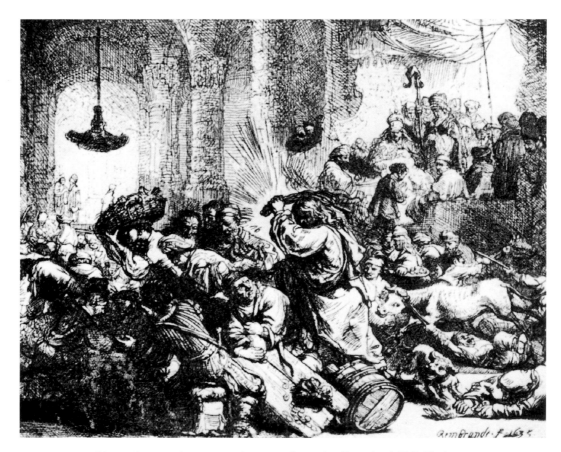

Christ driving the money-changers from the Temple. 1635. Etching.

Christ driving the money-changers from the Temple. (Detail).

24

Christt driving the money-lenders from the Temple. (Detail).

2. PORTRAIT OF AN OLD MAN

Oil on Canvas; restretched. 104.5 x 92 cm.
Monogram and date above right: RHL 1631.
St. Petersburg, Hermitage Museum.
Inv. N° 744. Acquired in 1769.

As a result of the numerous trips he had to make to complete his commissions, Rembrandt chose to leave his studio in Leyden for Amsterdam. The *Portrait of an old man* was amongst the works that drew him to the great city in 1631. The identity of the man with the ruff has long divided the specialists: some consider him to be a professor from the University of Leyden, whereas others suggest that he is probably a Venetian merchant or a high ranking dignitary.

Rembrandt, freed from the influence of the Flemish schools, nonetheless first made his name in this style by "interpreting" classical portraiture in his own particular manner: his model, unlike Rubens', no longer poses, imparts a simpler and more intimate tone to the portrait, whilst any pompous and official characteristics give way to what was to become known as the "spontaneity of spirit" of Rembrandt's characters. Rembrandt, in his works, attempts to capture the truth of the moment. This is reflected in his calm and measured brushstrokes, which strive to make the painting tangible, whilst each element of the portrait is imbued with realism, through the use of colour, the texture of the pictorial subject matter and the manner of applying the paint.

This portrait, much appreciated by the sitter, was at the origin of the success Rembrandt encountered from the moment he settled in his Amsterdam studio.

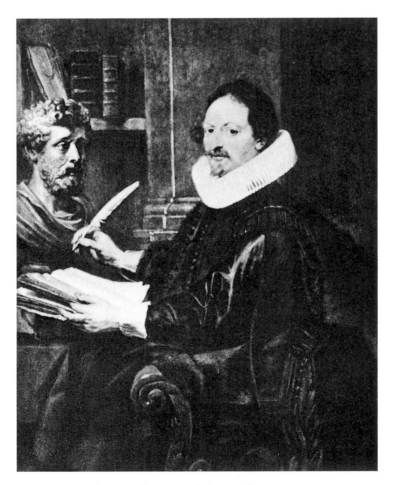

RUBENS. Portrait of Caspar Gevartius.
C. 1628. Museum of Fine Arts, Antwerp.

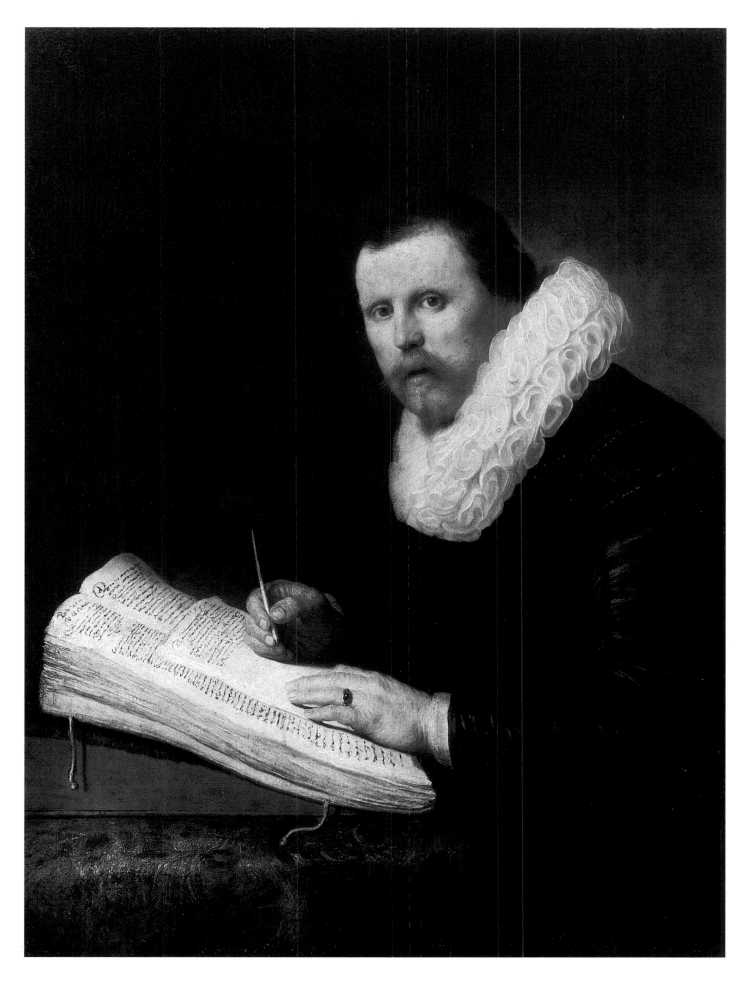

27

*Portrait
of an old man.*
(Detail).

*Portrait
of an old man.*
(Detail).

31

3. THE ADORATION OF THE MAGI

Oil on paper glued to canvas; restretched.
45 x 39 cm.
Grisaille.
Signed and dated at the bottom, a little to the right:
Rembrandt f. 1632.
St. Petersburg, Hermitage Museum.
Inv. N° 7765. Acquired in 1923.

This authentic replica of the *Adoration of the Magi* held in the Gothenburg Museum, forms part of a collection of grisailles that Rembrandt painted from the 1630s onwards. Seven of his canvasses, generally two-toned, are currently known worldwide. This work was only recently recognised as Rembrandt's, and was for a long time relegated to the reserve collection of the museum, known only to the Hermitage collectors. An X-ray analysis of the painting revealed that Rembrandt performed a number of modifications during the execution of this piece, which indicated that this could not be a copy. The artist was largely inspired by the portraits created by his teacher Peter Lastman and by the masters of the Italian Renaissance, as well as by Rubens, whose engravings Rembrandt so admired and who was also the author of a number of paintings dealing with the same subject. Two other drawings by Rembrandt on the theme of the Adoration are in existence: the first is kept in the Prints Room in Berlin, the second in the National Library in Turin.

Neither drawing is dated, but they were most probably created at the beginning of 1630, although certain experts have put forward the possibility of a later dating. Simpler in style, they are probably of a later date than the grisaille in the Hermitage, which is first mentioned in the 1714 inventory of the collection of the Prince of Orange.

Adoration of the Magi
Drawing. C. 1632. Berlin - Dahlem.

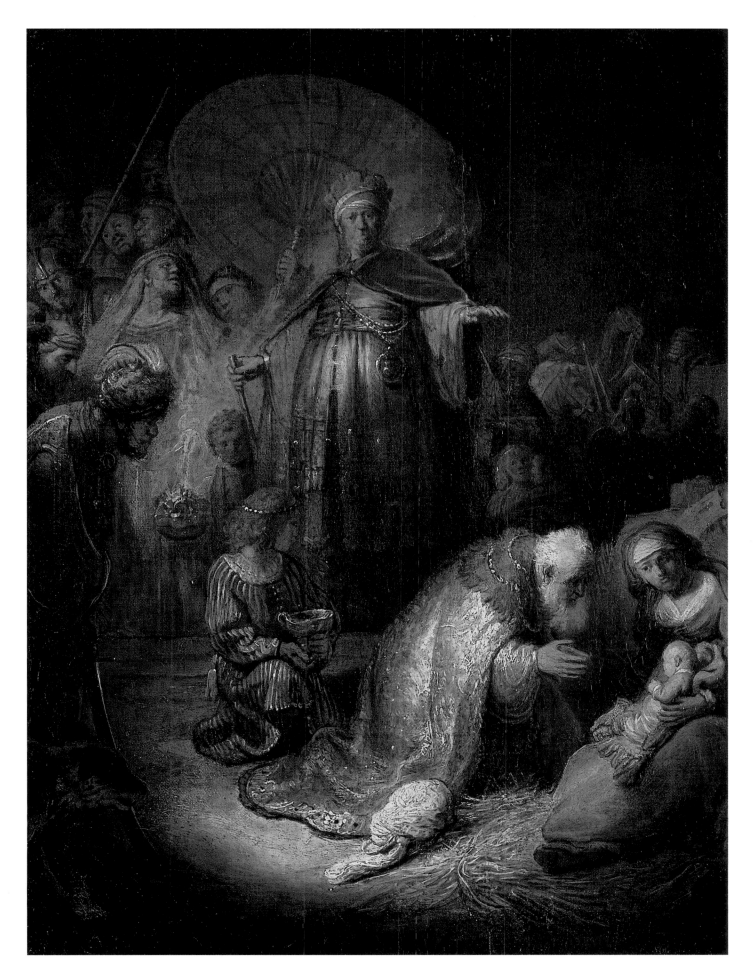

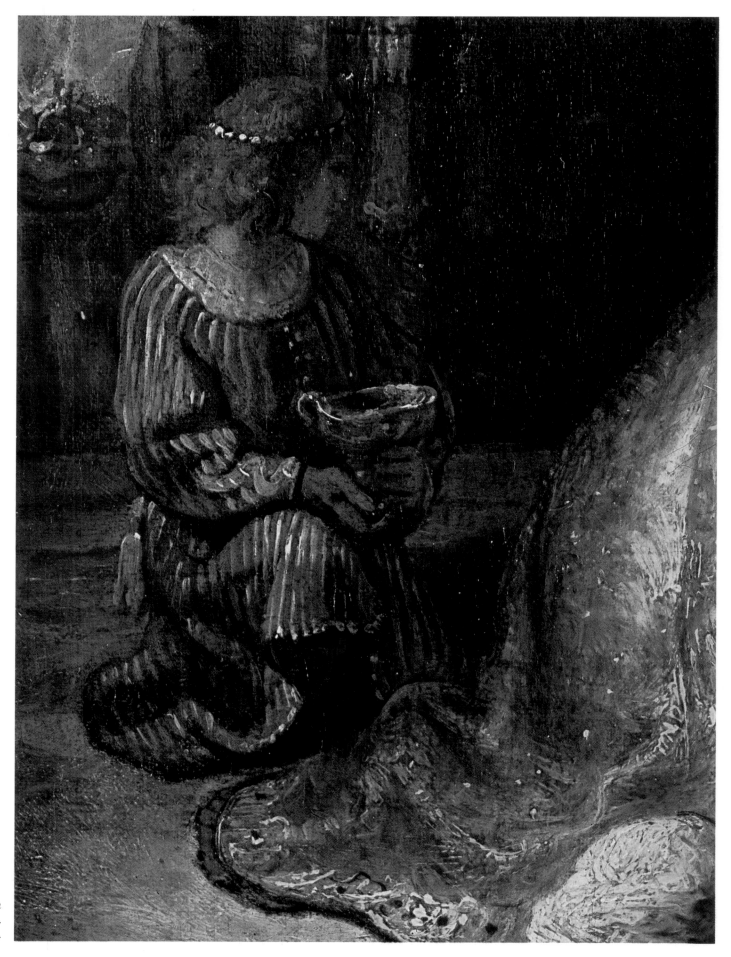

Adoration
of the Magi.
(Detail).

34

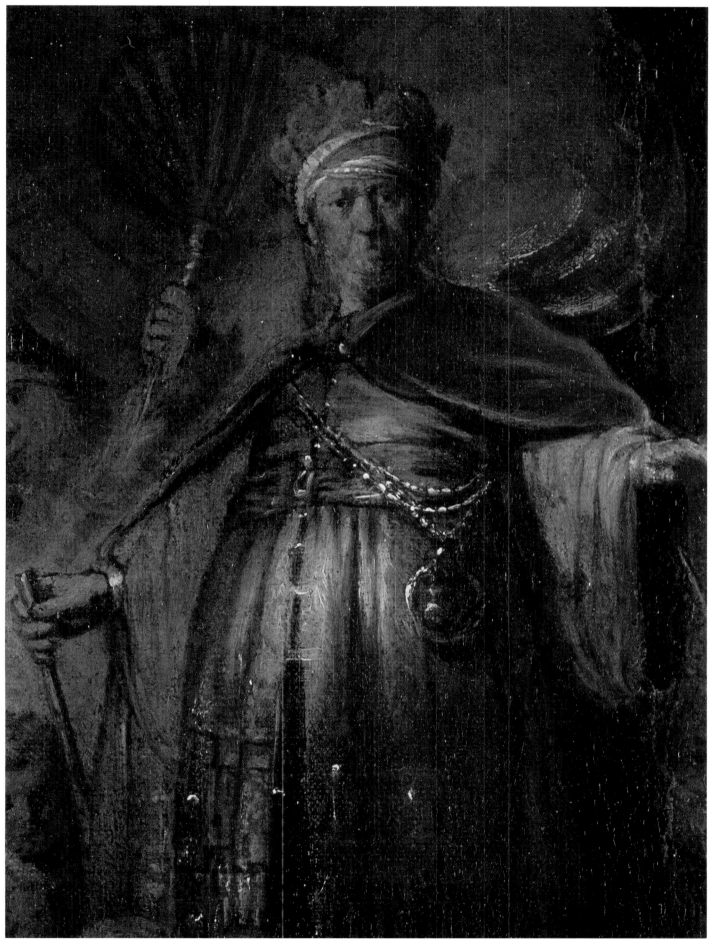

*Adoration
of the Magi.*
(Detail).

35

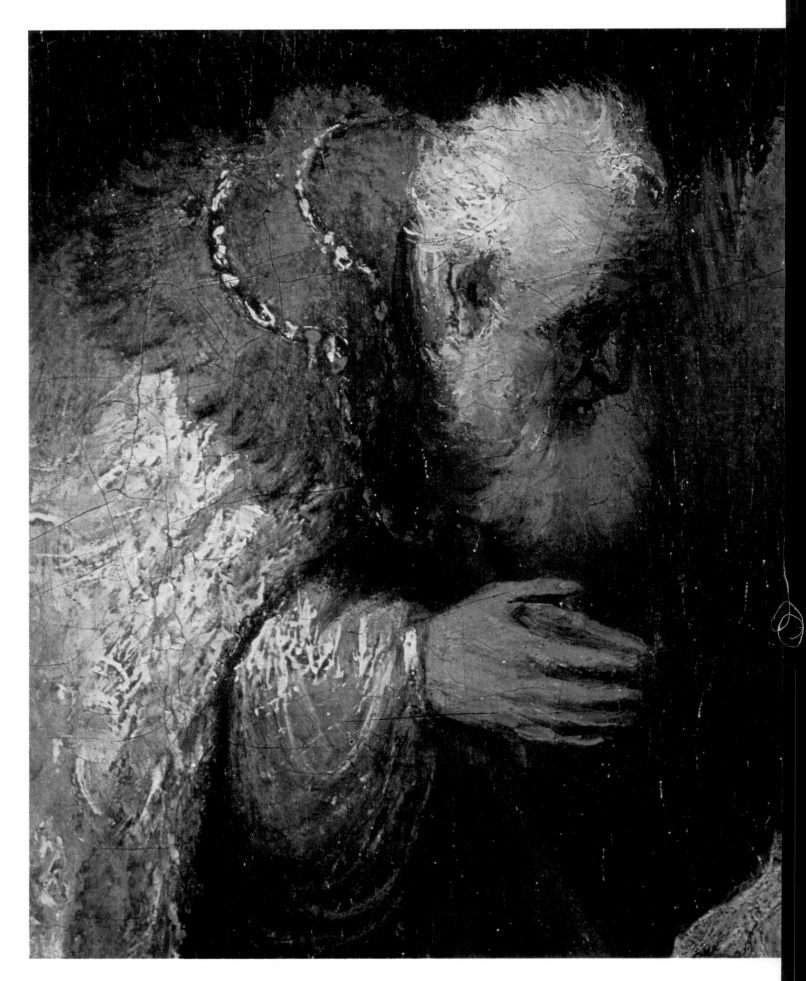

36

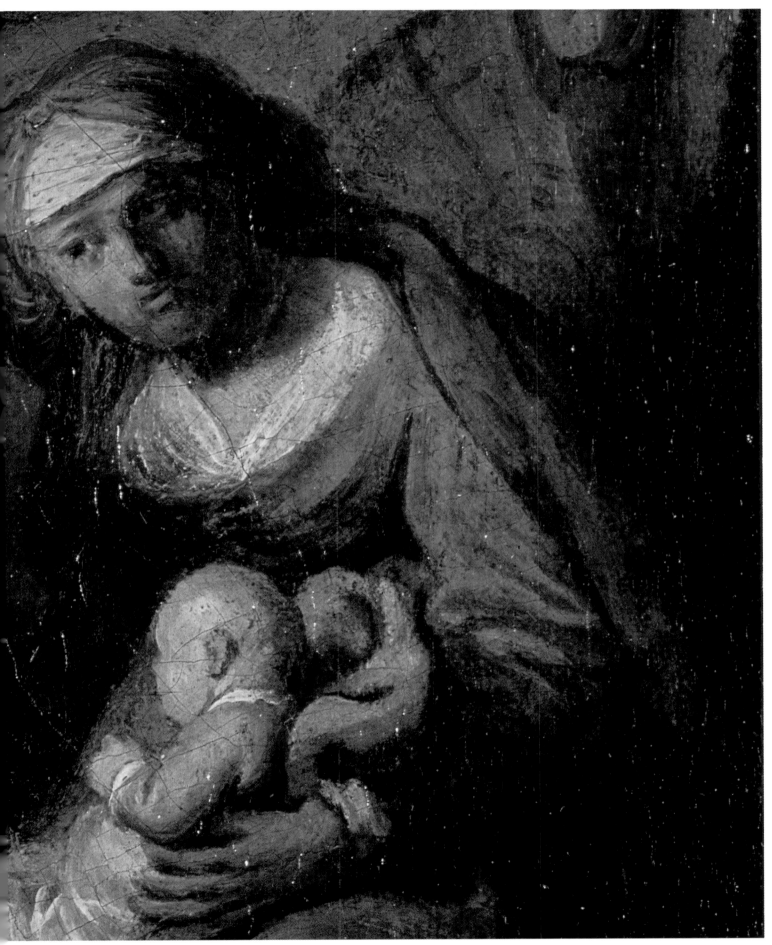

Adoration
of the Magi.
(Detail).

37

4. PORTRAIT OF A BOY

Oil on wood (oak); restretched. 67 X 47.5 cm.
Rounded at the top and bottom.
St. Petersburg, Hermitage Museum.
Inv. N° 724. Acquired *circa* 1783.

This is probably a portrait of Gerrit van Uylenbourgh, Saskia's son, whom he strikingly resembles, and that Rembrandt painted on numerous occasions, from the moment he moved in with them. Here again, the identity of the painter has split specialist opinion, and hence required closely controlled analyses of the work. In 1863, the Hermitage catalogue still attributed the painting to Govaert Flinck, although no mention of this work is found in the artist's monograph, since this group of portraits (which includes two miniatures) also seemed to belong to the work of Jouderville, one of Rembrandt's students.

Rembrandt specialists have now come to the conclusion that the painting can legitimately be attributed to the Dutch master, since Flinck had not attained such a mastery of portraiture in 1633-1634, and because half a dozen years later, when Flinck reached his artistic peak, the child would have been older.

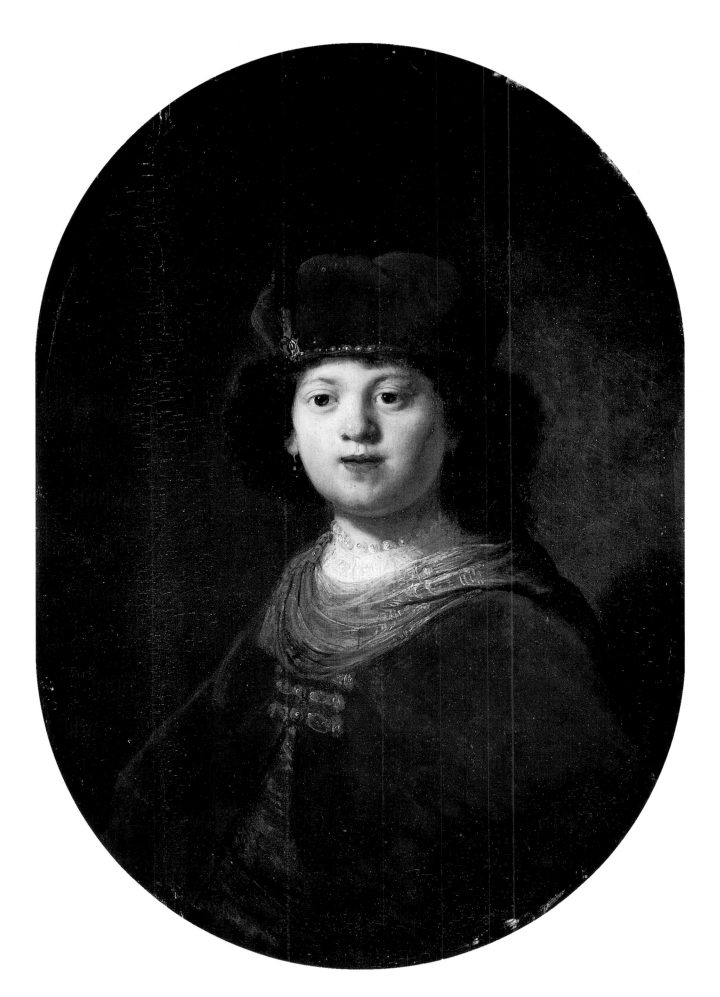

39

5. YOUNG MAN WITH A MOUSTACHE

Oil on wood (oak); restretched. 70.5 X 52 cm.
Oval.
Signed and dated on the right, above the shoulder:
Rembrandt. f. 1634.
St. Petersburg, Hermitage Museum.
Inv. N° 725. Acquired in 1829.

Rembrandt, having become the most fashionable portrait painter in Amsterdam, completed many commissions in the mid 1630s: portraits in full apparel, full length portraits, half-length portraits and busts. *Young man with a moustache*, along with its companion piece, the portrait of *A young woman with flowers in her hair*, which is in the National Gallery of Scotland in Edinburgh, are among Rembrandt's most modest and hence most accessible portraits. Judging by the age of the models, this pair of portraits probably constituted a wedding set. The stiffness of the pose, the models' formal dress and their slightly fixed smile are masterfully counterbalanced by the oval shape of the frame and the sparkle in their eyes. These two portraits only assumes their full meaning when placed together, failing which the work is not complete. The two portraits, that were intended to face each other, differ in composition as the young man, whose portrait would naturally be placed on the left, does not enjoy the same light as his spouse. It is not surprising then that the wife's portrait possesses a greater pictorial quality. In the portrait of the young man, as in all of Rembrandt's similar portraits, the painter, for practical reasons, leaves a large part of the character's face in shadow. Moreover, Rembrandt employed impasto only in the areas with plenty of light, whereas in the shaded parts the brushstrokes are often transparent, and the grain of the canvas, the preparation work and even occasionally the structure of the wood are apparent, imparting a negligent, even, to some extent, an unfinished look to the portrait of the young man.

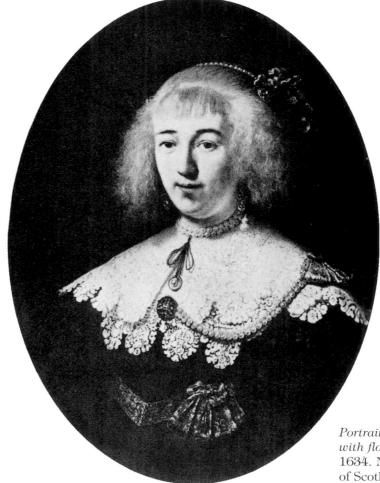

Portrait of A young woman with flowers in her hair. 1634. National Gallery of Scotland, Edinburgh.

40

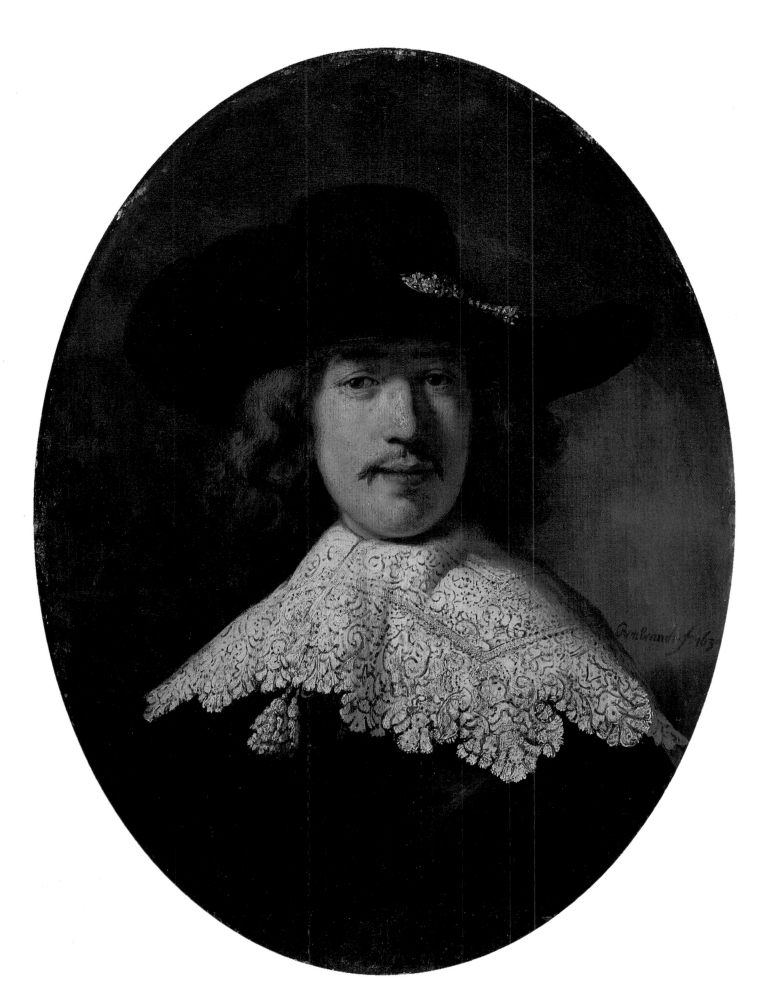

41

6. SASKIA IN ARCADIAN COSTUME

Oil on canvas; restretched. 125 x 201 cm.
Signed and dated at the bottom to the left: Rembrandt. f. 1634.
St. Petersburg, Hermitage Museum.
Inv. N° 732.
Acquired between 1770 and 1775.

Under the guise of Flora, the goddess of flowers and Spring, Rembrandt depicted his first wife, Saskia van Uylenbourgh the daughter of the burgomaster Leewerden Rumbartus van Uylenbourgh. Engaged in 1633, the young couple were married the following year, and it was probably on this occasion that the artist created this work. A silver point drawing (in Berlin), an oil paint portrait (in Dresden) as well as a variation on the Hermitage painting (in London) are also among the portraits of Saskia which belong to this happy period in Rembrandt's life.

Saskia, still very young, seems a little disconcerted by her costume: her head is bowed under the weight of her heavy crown and her gaze is averted, her right hand timidly holds the crozier, and she gathers the richly decorated folds of her mantle in a faintly embarrassed manner. A year later, in the painting in the National Gallery in London, Saskia, radiant with happiness from her marriage, slips easily into her role. The young girl's gestures are poised and her bearing haughty, her gaze resembling that of a goddess in the full measure of her power. Peter Lastman's influence is discernible in the execution of the draperies and in the way his student depicted the costume; however, the variety in the brushwork – delicate and fluid in the modelling of the face and hands, employing impasto to render the impression of relief in the material and folds of the costume, beautifully graphic in the depiction of the flowers and leaves – betrays the work of an artist in the process of developing his own style and technique.

Before assuming its final title, the Hermitage painting was known under a variety of names, inspired by various situations in which Saskia's presence made it possible to mistake the painting for an historical depiction: thus Saskia was believed to be the *Jewish Bride* and the *Shepherdess Against a Landscape*. However if Flora's manners were so often modified, it was equally because of the fashion Rembrandt followed – at the time – of creating various paintings inspired by the same subjects, including *Young Woman with a Wide Brimmed Hat and crozier* (kept in the Prints Room in Amsterdam), and which some specialists imagine to be a study for the figure of Flora. Other works strengthen this theory, all typical of the first half of the 1630s and which all refer to mythology: examples include *Bellona* in the Metropolitan Museum of Art in New York(1633), *Sophonisba receiving the poisoned cup* in the Prado Museum in Madrid and *Minerva* in the Julius Weitzner collection in London (1635).

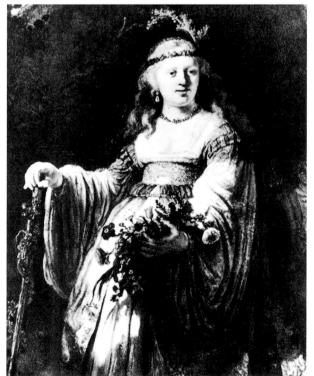

Saskia in Arcadian Costume.
(Flora) National Gallery, London.

42

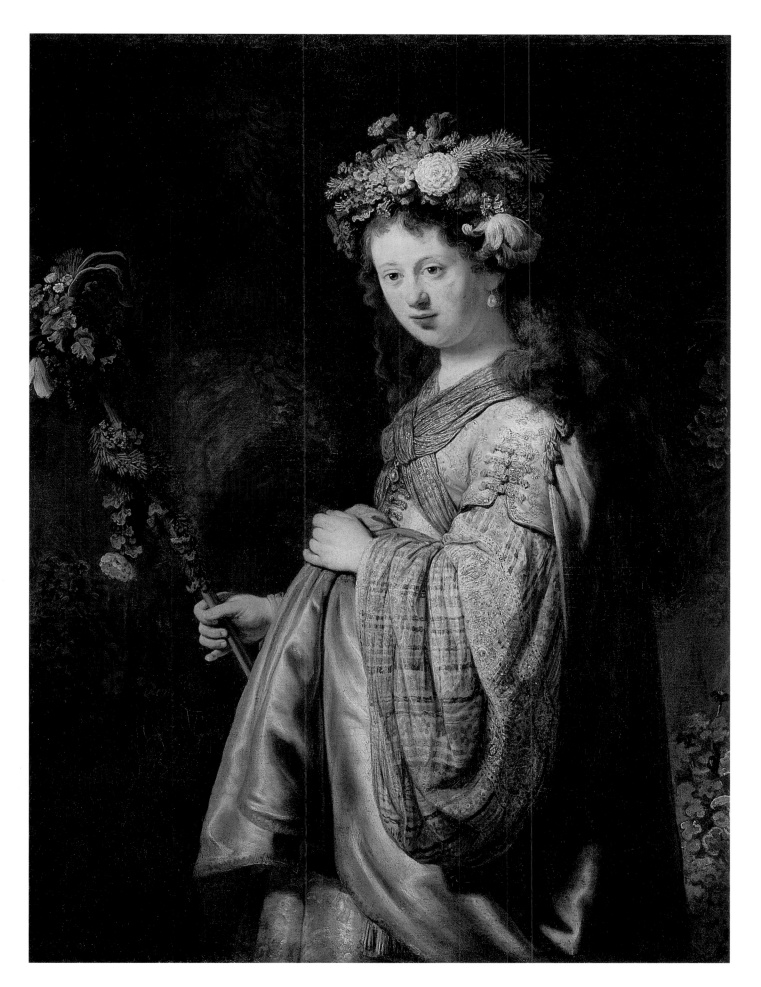

44

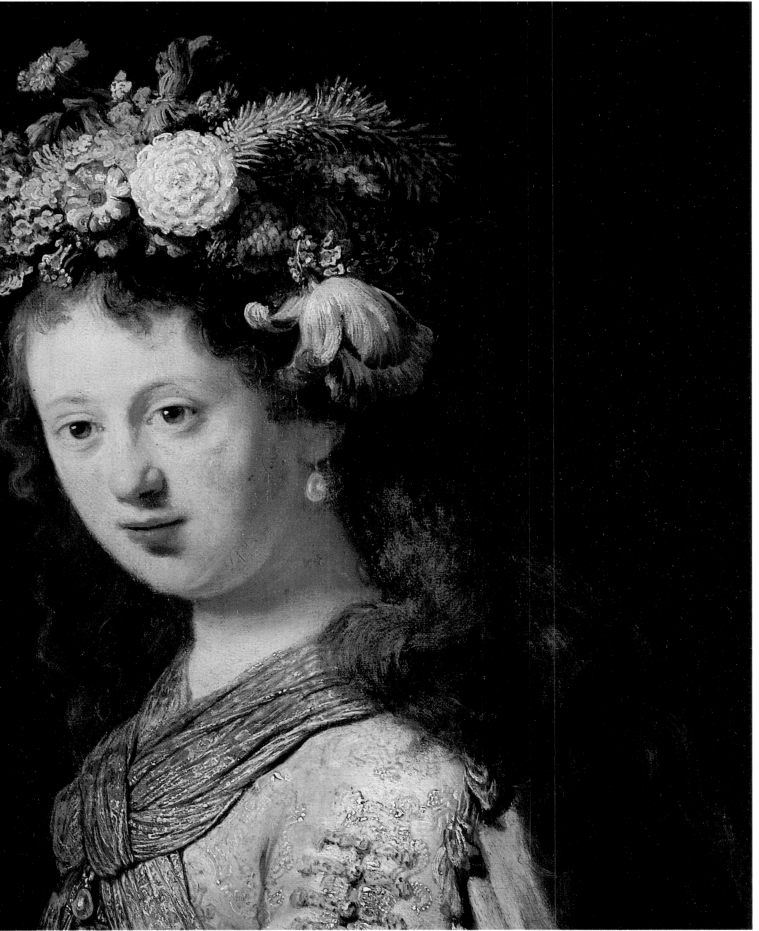

Flora.
(Detail).

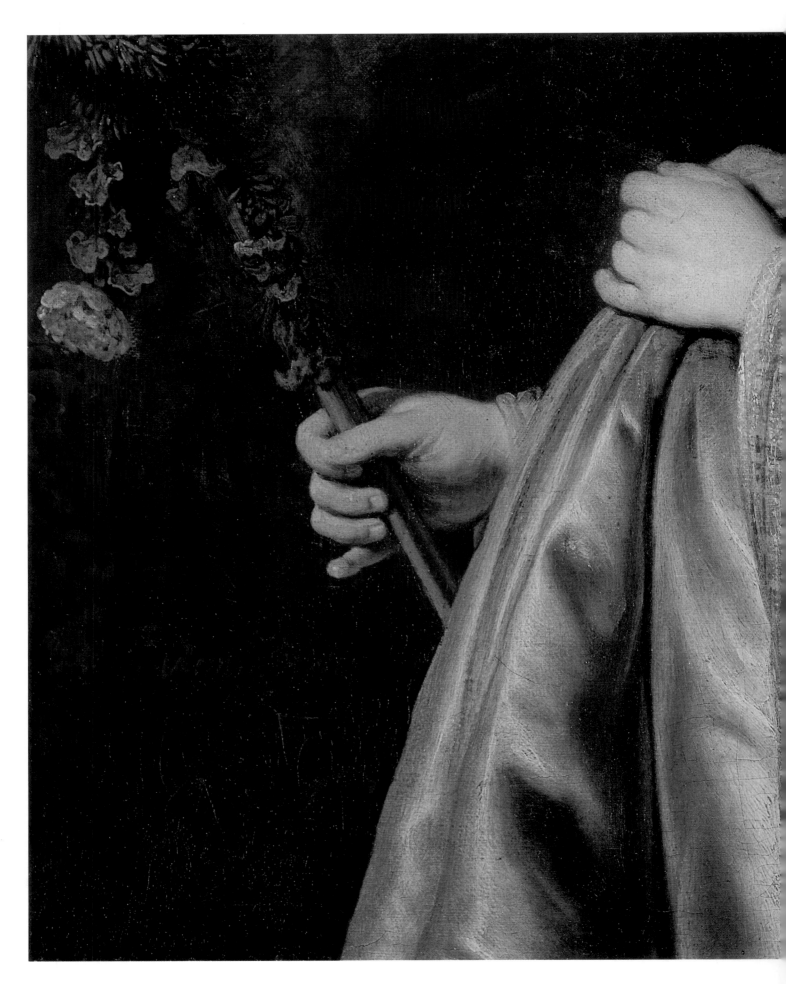

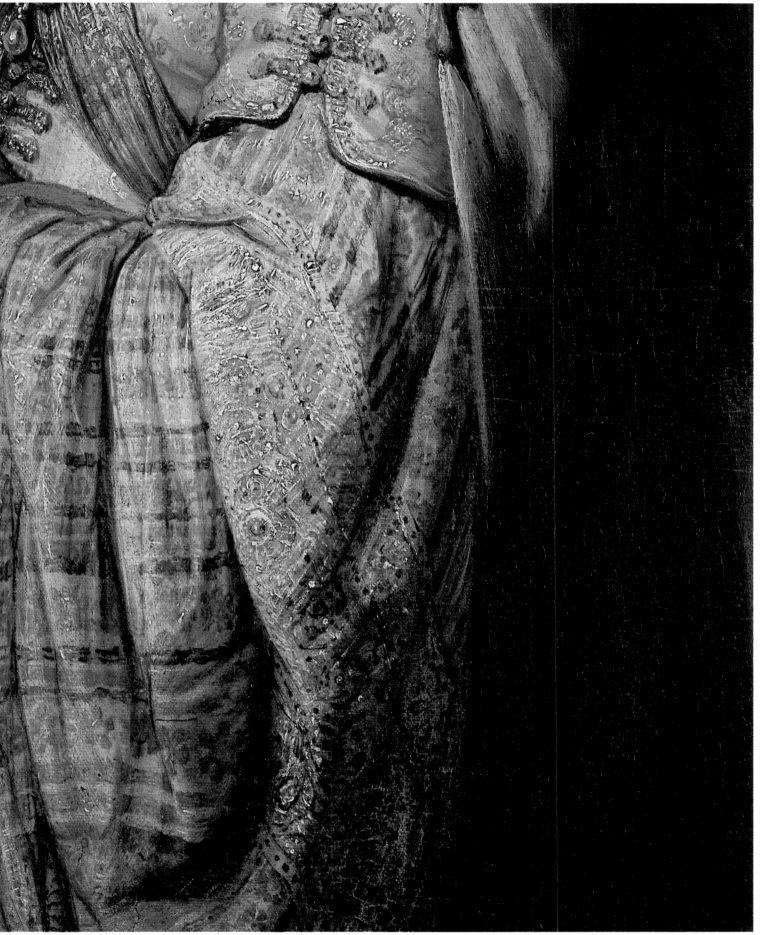

Flora.
(Detail).

7. THE RISEN CHRIST SHOWING HIS WOUND TO THE APOSTLE THOMAS

Oil on wood (oak). 50 x 51 cm.
Signed and dated on the left at the bottom: Rembrandt. f. 1634.
Moscow, Puchkin Museum.
Inv. N° 2619 since 1930, after having been acquired for the Hermitage Museum in St. Petersburg in 1764.

The scene of the risen Christ showing his wounds to St Thomas the Apostle was often depicted by 17th century painters, to whom the topic seemed both spectacular and mystical. In Rembrandt's work, every device is used to place the figures of Christ and the apostle in stark relief, to reveal the emotions seizing each character: the main group, forming a semi-circle, is in opposition to the figure of St Thomas the apostle, filled with fright.

From a pictorial standpoint, the canvas is carefully painted only in the central part, which is abundantly lit; elsewhere the details are executed more or less summarily. The artist's unique style is particularly apparent in the figure of the sleeping man and in the objects which surround him. His dark red coat is painted with quick, fluid brushstrokes, whilst large black strokes outline the darkest parts of his body. His features are nonetheless perfectly executed, with a sure hand which brings to mind, by the boldness of their execution, the artist's drawings. Although this part of the painting remains incomplete, the picture as a whole, on the other hand, is delicately and carefully completed: one need only examine the fine embroidery on St Thomas' coat which is a sure witness to the artist's mastery and experience. The radioscopy study reveals, moreover, that the artist modified the canvas a number of times during its creation.

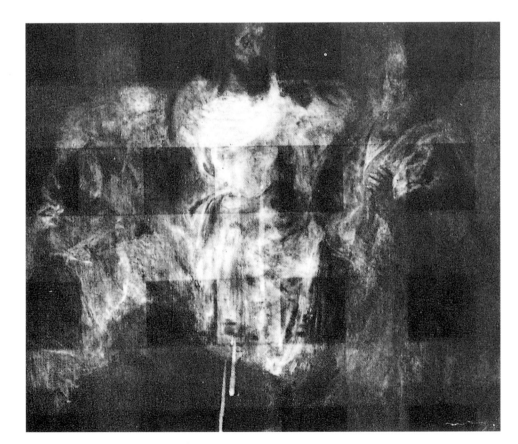

The Risen Christ Showing His Wounds To The Apostle Thomas. Detail (X-ray print).
Puchkin Museum, Moscow.

48

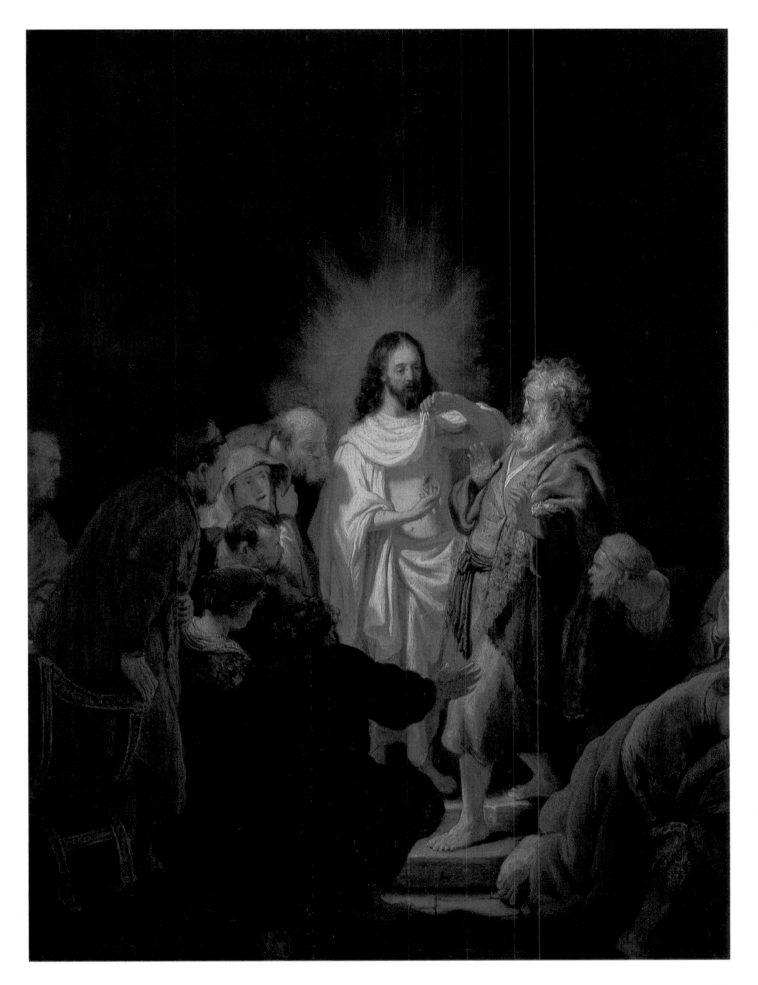

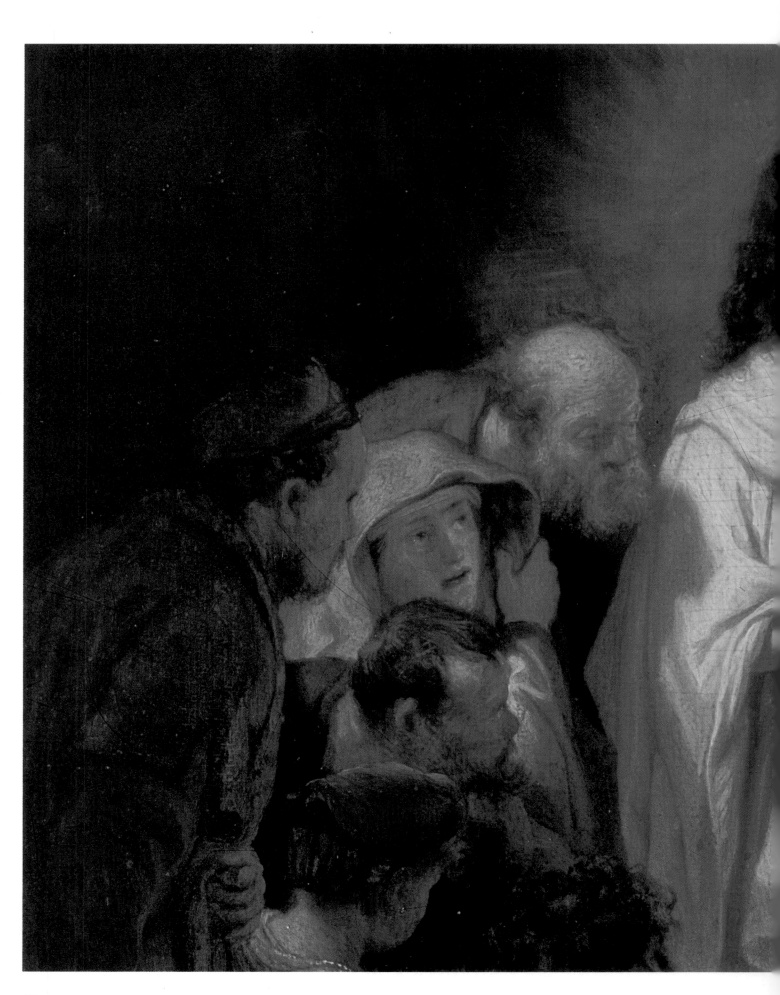

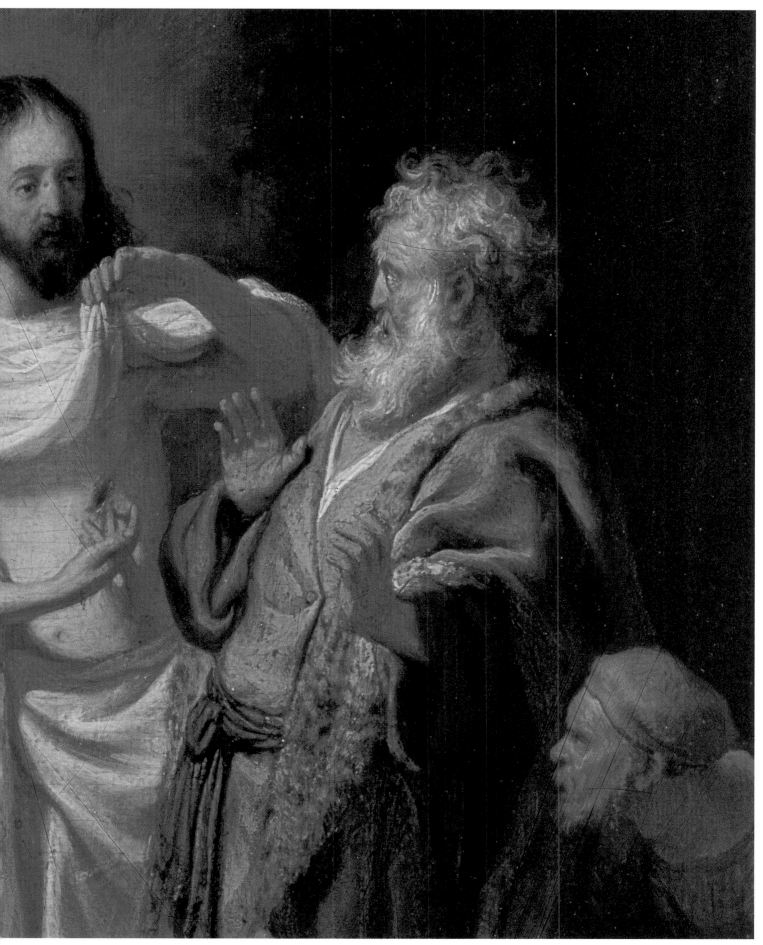

The risen
Christ showing
his wounds
to the apostle
Thomas.
(Detail).

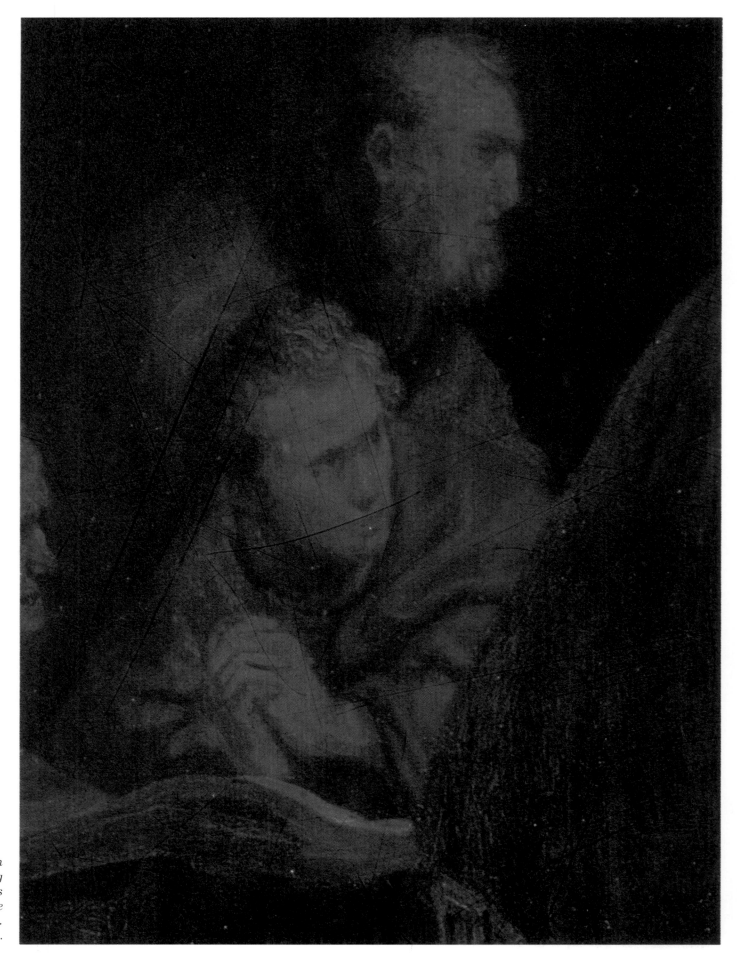

The risen Christ showing his wounds to the Apostle Thomas. (Detail).

52

The risen Christ showing his wounds to the apostle Thomas. (Detail).

53

*The Descent
from the Cross.*
(Detail).

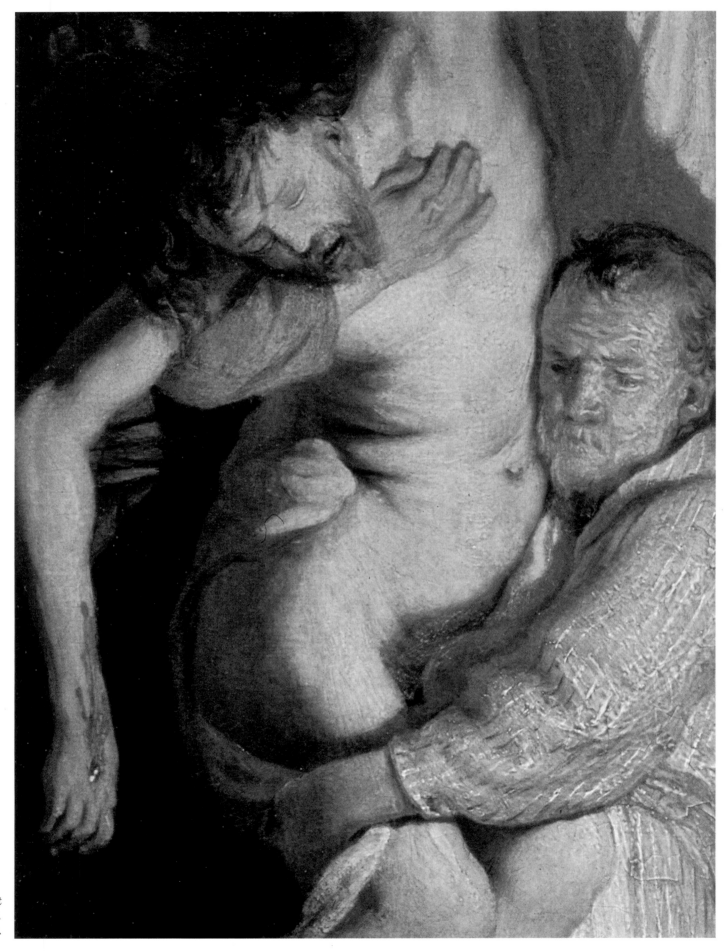

The Descent from the Cross. (Detail).

58

The Descent from the Cross. (Detail).

59

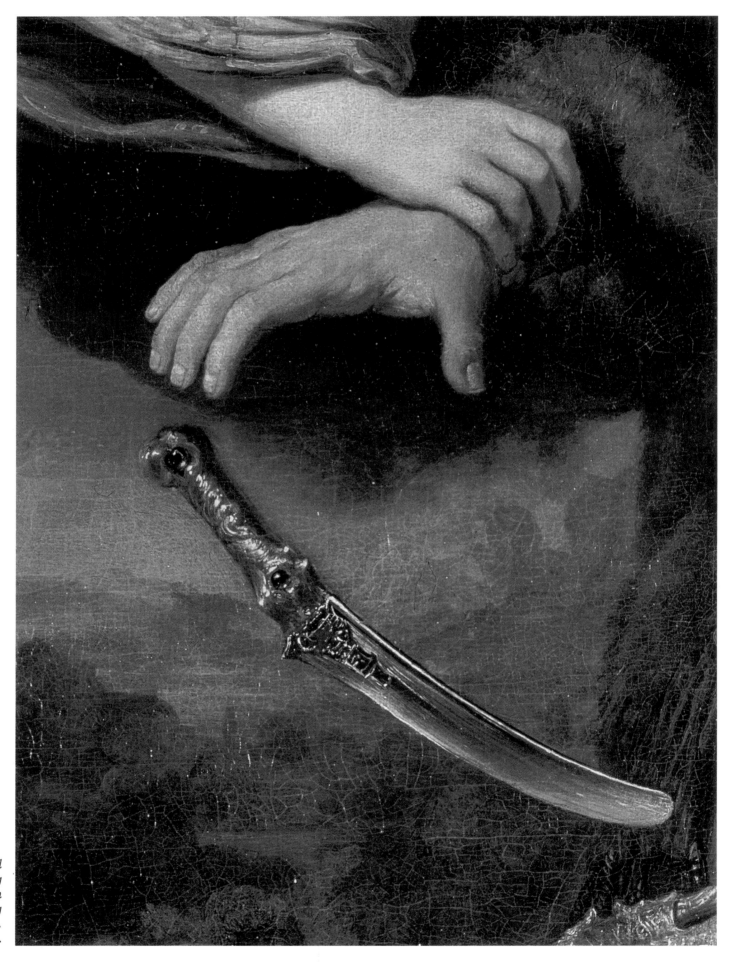

The Angel stopping Abraham from sacrificing Isaac. (Detail).

62

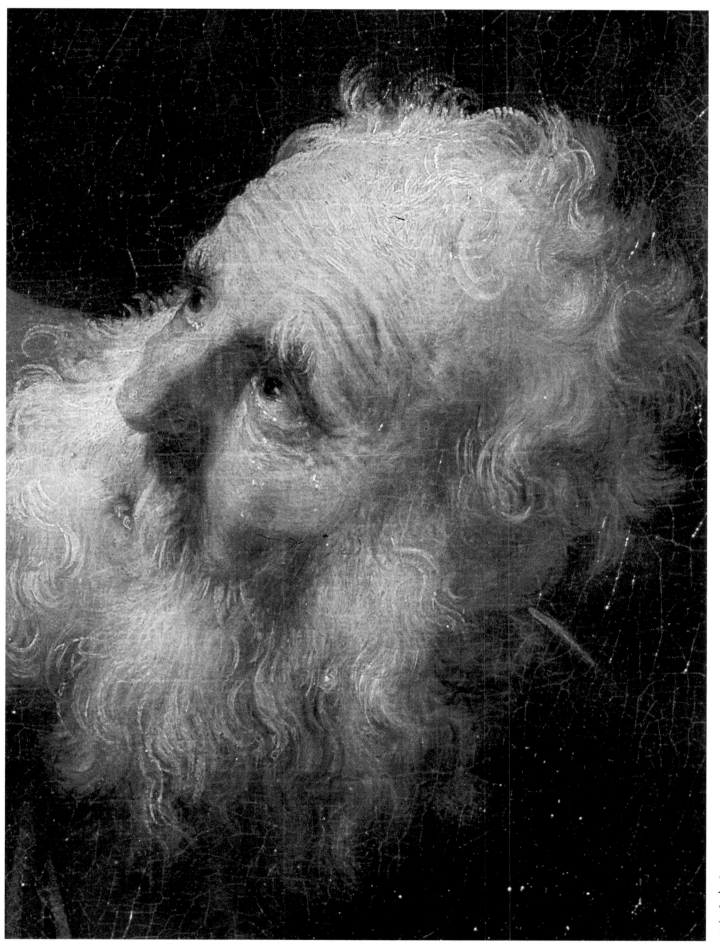

*The Angel
stopping
Abraham from
sacrificing
Isaac
(Detail).*

63

64

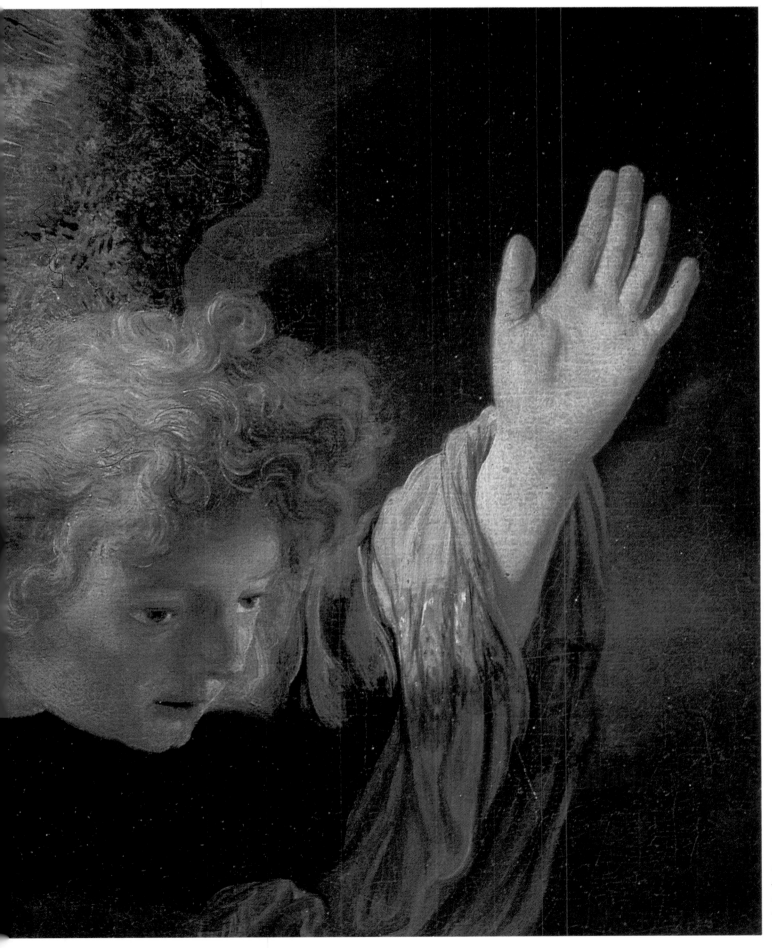

*The Angel
stopping
Abraham from
sacrificing
Isaac.
(Détail).*

65

10. THE PARABLE OF
THE LABOURERS IN THE VINEYARD

Oil on wood (oak); reinforced. 31 x 41 cm.
Signed and dated at the bottom to the right: Rembrandt. f. 1637.
St. Petersburg, Hermitage Museum.
Inv. N° 757. Acquired in 1772.

This depiction of the parable of the labourers, in which Rembrandt has chosen to concentrate on the moment of payment, is highly unusual in the way the artist has stressed the labourers' discontent. The master and his two workers fill all the space in the painting, reflecting their importance in the biblical text. The human feel to this work and the great truth which emanates from it, immediately attracted the attention of the critics who sensed its symbolical strength: "Rembrandt transforms the payment scene into a highly topical work", Knipping commented in his book on Counter-Reformation Iconography in Holland. "All in all, added R. Hamann, the painting represents the office of any merchant in Amsterdam." Transcending the simple genre scene, the painting can effectively be approached from a modern standpoint and the "moral" contained in it surpasses the simply historical to reveal instead the timeless quality of the parable. The cat placed in the forefront of the painting, seizing a mouse in its paws, confirms the artist's intention to create a symbolic work; indeed the popular Dutch saying "to live like cat and mouse" reminded the artist of Christ's words to his disciples, and highlights all the animosity which existed in the society of his time, which was governed by the arbitrary and the law of the strongest.

Apart from another painting whose authorship has not been unequivocally determined, a whole series of Rembrandt's drawings on the same subject have been preserved, dating from between 1640 and 1650. *The Parable of the Labourers in the Vineyard* played an important role in the artistic life of Rembrandt's time, and though they were not all students of the great Amsterdam painter, many artists were in one way or another, and at varying times, inspired by this work.

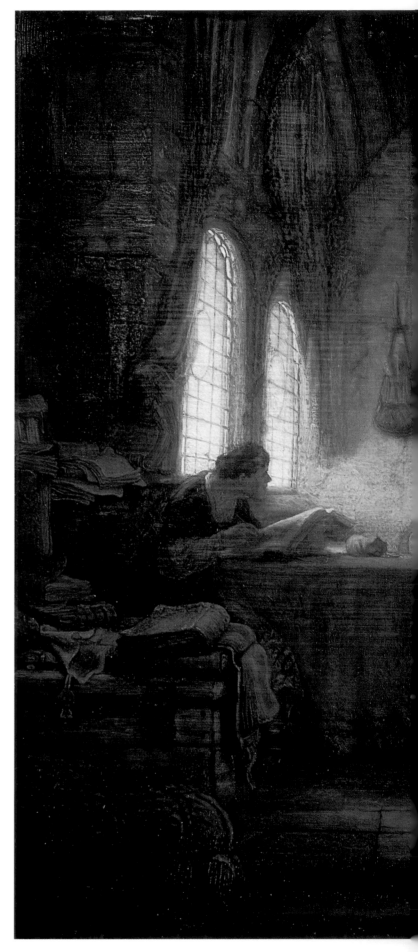

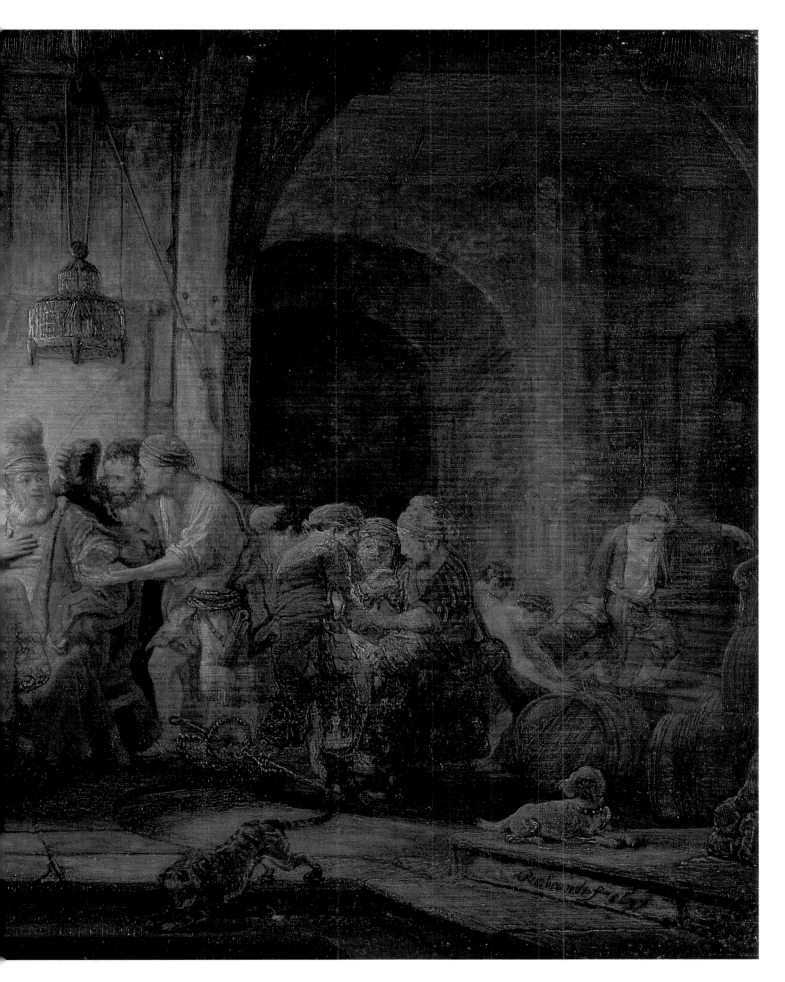

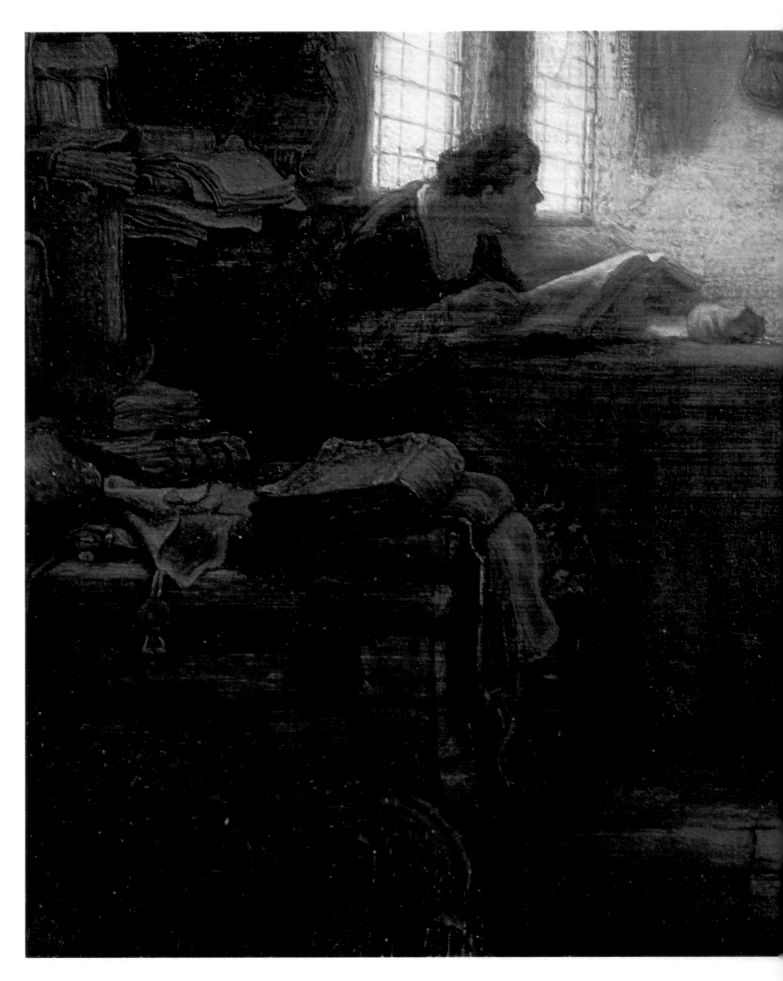

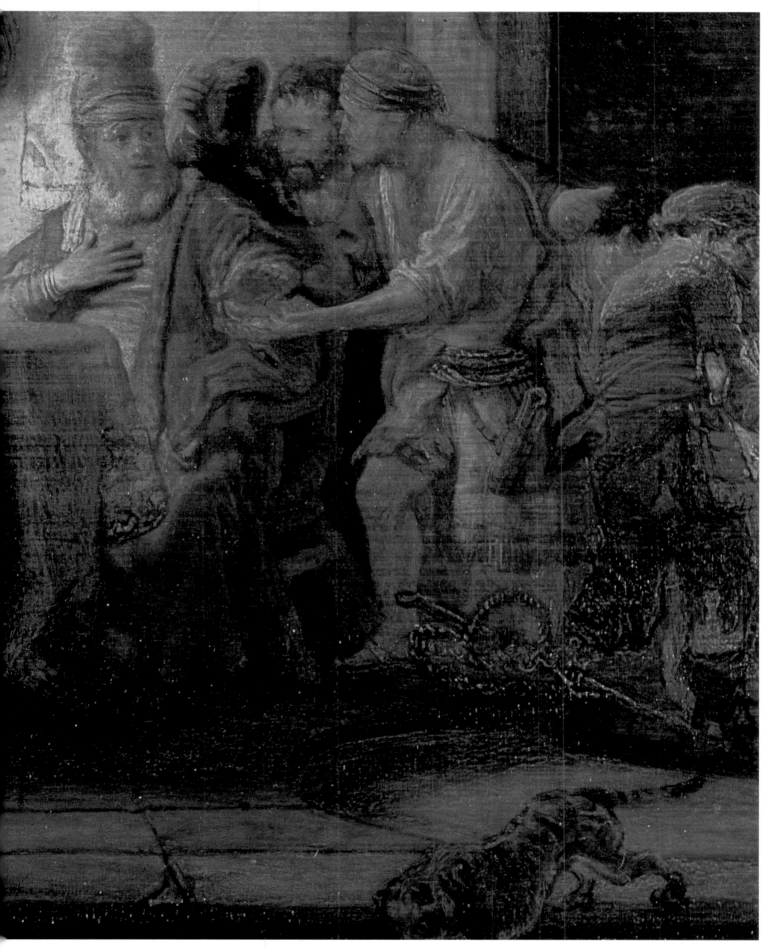

The parable
of the labourers
in the vineyard.
(Detail).

11. BAARTJEN MAERTENS, WIFE OF HERMAN DOOMER

Oil on wood (oak); reinforced. 76 x 56 cm.
Signed at the bottom on the left, on the background:
Rembrandt. f.
St. Petersburg, Hermitage Museum.
Inv. N° 729. Acquired circa 1797.

It was not until 1909 that the figure in this undated portrait was identified as Herman Doomer's wife, a cabinetmaker who supplied Rembrandt with his frames, and whom the artist painted in 1640. Their son Lambert Doomer, a landscape painter, was, moreover, one of Rembrandt's students. With this portrait, the artist bequeathed us a surprising and sympathetic image of a commoner's wife, typical of the class which Rembrandt felt so at ease with. This work, along with the portrait of Herman Doomer, is unusual in Rembrandt's art at this time, when most of his paintings were commissioned by the mercantile bourgeoisie. A comforting intimacy and warmth emanates from this work, in spite of the formal dress which the model is here wearing. Her welcoming face and eyes, and the hint of a smile on her lips nevertheless fail to disguise her embarrassment in front of the artist's brushes. In the first version of the portrait (visible under X-ray), the model is seen playing with a handkerchief. Rembrandt must have decided, however, that this prop would detract from the overall harmony of the portrait.

This is the artist's first work in which he uses chiaroscuro as a psychological backdrop in order to convey the figure's inner, private world. At the beginning of the 1630s, Rembrandt employed stark contrasts in light to "dramatise" his compositions. Starting with Baartjen's portrait, the artist came to use this perfectly mastered technique in every portrait. The transition from light to dark in the painting is hardly visible, since the artist proceeded to paint with overlapping, semi-transparent strokes, creating a glazed impression, rendering the progression from one colour to another practically imperceptible. Slight shadows glide across the model's face, and the reflection of the white collar on the cheeks gives them a faint sylphlike halo.

Following their mother's last wishes, the Doomer children had five copies of Rembrandt's two portraits made, of which a few have survived down to the present day.

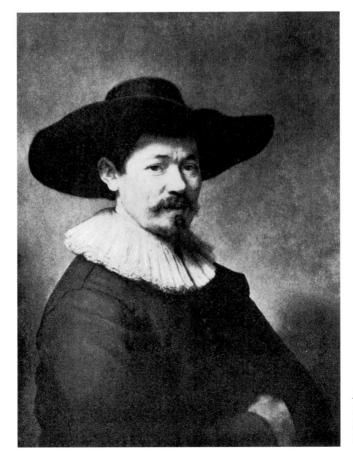

Herman Doormer.
1640.
Metropolitan Museum of Art,
New York.

70

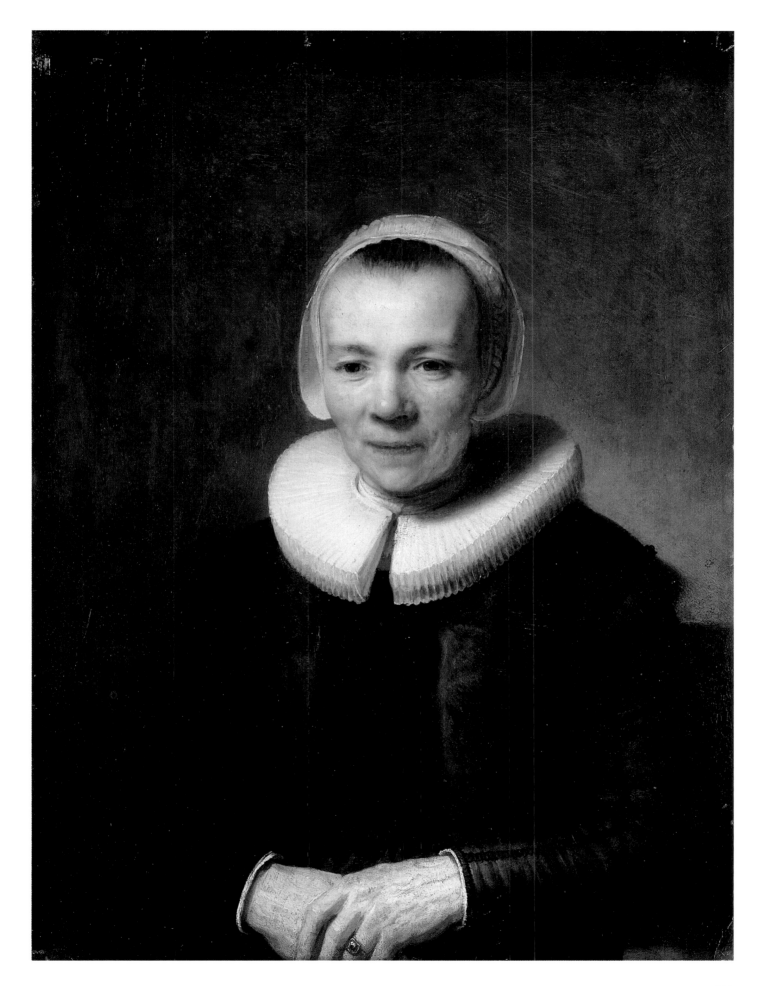

Baartjen Maertens,
wife of Herman Doormer.
(Detail).

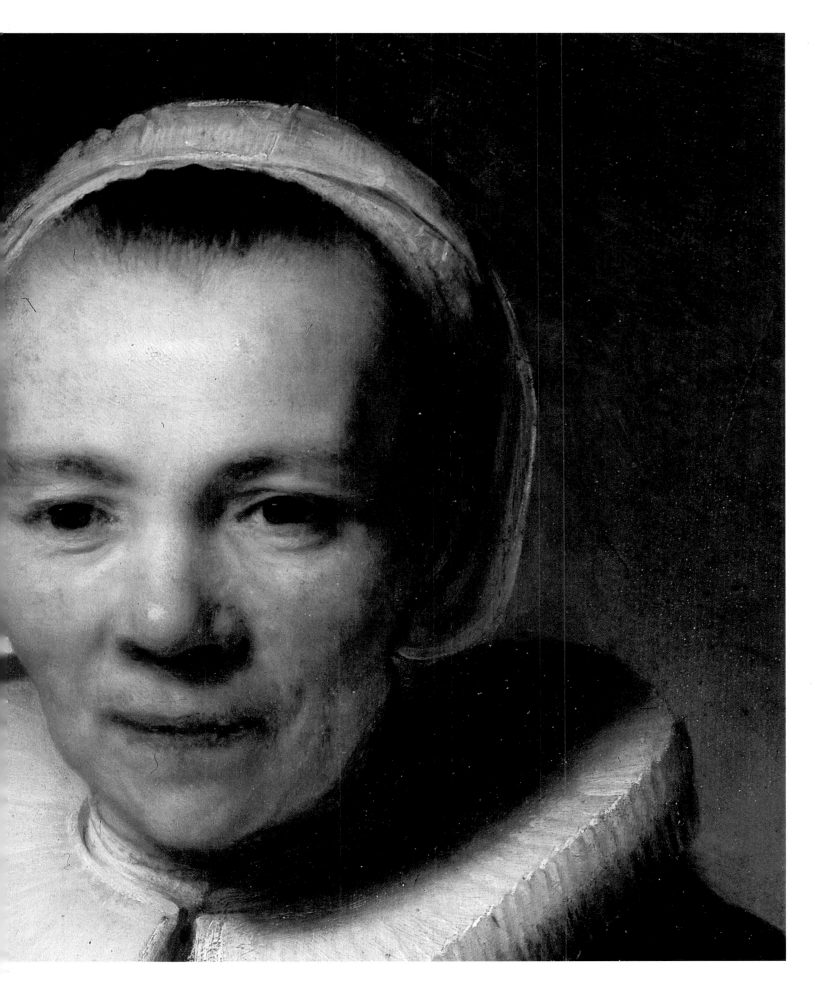

12. DAVID AND JONATHAN

Oil on wood (oak); reinforced. 73 X 61.5 cm.
Signed and dated in the middle at the bottom:
Rembrandt. f. 1642.
St. Petersburg, Hermitage Museum.
Inv. N° 713. Acquired for the czar Peter Ist
in 1716; transferred to the Hermitage in 1882.

The young David, fallen into disgrace at king Saül's court, says his farewells to his friend Jonathan, the king's son. The scene between the two friends is very moving: "They kissed each other, and cried together until David's sobs became excessive", seems to be Rembrandt's interpretation of Samuel's verse (XX/41). In the old inventories pertaining to the Hermitage and the imperial palaces, this scene was usually mistaken for the *Return of the Prodigal Son* or the *Reconciliation of Jacob and Esaü*. It was not until 1925 that the scene was correctly interpreted, after a detailed analysis of the biblical text and the painting established beyond a shadow of a doubt the nature of the scene depicted by the artist. A short while later, archives concerning an auction held in 1716 revealed that the painting, in the van Beuningen inventory, did effectively represent Jonathan and David.

Amongst Rembrandt's drawings that depict similar scenes, the closest version is found in the Teyler Museum in Haarlem. Dating from 1642, this drawing represents the *Return of the Prodigal Son*, but probably foreshadows the Hermitage's *David and Jonathan*.

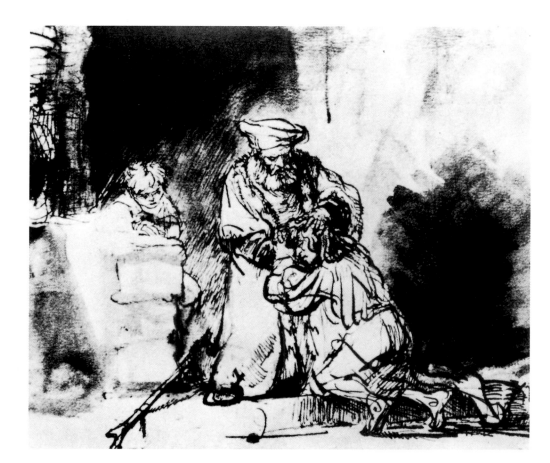

Return of the Prodigal Son.
Drawing. Teyler Museum, Haarlem.

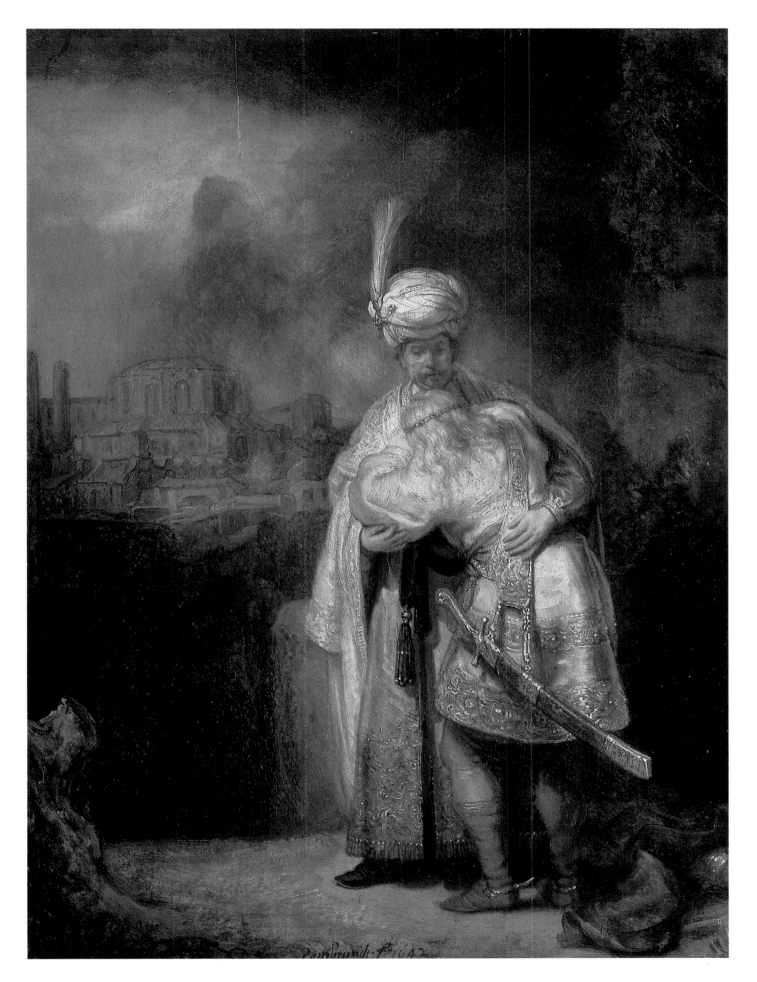

76

*David
and Jonathan.*
(Detail).

13. AN OLD WOMAN
IN AN ARMCHAIR

Oil on wood; Reinforced. 61 X 49 cm.
Signed and dated on the right, in the centre of the wall:
Rembrandt. f. 1643.
St. Petersburg, Hermitage Museum.
Inv. N° 759. Acquired in 1767.

The portrait of the *Old Woman in an Armchair* is one of Rembrandt's few works for which preparatory studies exist. The Count of Seylern's collection, in London, includes a black stone drawing, on which is depicted a seated lady in the same position, and wearing the same veil and dress. The spectacles do not figure in this version, and the drawing differs in certain detailing of the veil and the expression of the model, yet there is no doubt that the painting and the drawing share a common origin.

Another portrait, entitled *Rembrandt's Mother*, dating from 1639 and kept in the Kunsthistorisches Museum in Vienna, seems to have been painted under the same conditions – or else in the same spirit. Certain critics' attempts to link the models in the paintings with Titan's nurse have never been recognised, in the same way that it is now impossible to rename the *Old Woman in an armchair*, as was attempted a few years ago. On the other hand, it is not impossible that the lady with the spectacles was indeed Willemsdochter van Zuytbroek, Rembrandt's mother, who died in 1640, and possibly painted here from memory. A great number of corrections visible to the naked eye, give this wistful work a less energetic atmosphere, whilst the condition of the painting itself, darkened by a dense layer of varnish, plays an important role in defining our approach to the work today. Rembrandt's concern and sorrow over the ineluctable passage of time, and the loss of precious memories, are also strongly apparent in this work. It does not seem to be possible to establish with certainty whether all the corrections were carried out by Rembrandt, or whether they were added at a later date. In fact, the authenticity of the painting itself was recently called into doubt by certain experts who attribute it instead to one of the master's students, notably Abraham van Dijck, but this question cannot be fully addressed without careful scientific analysis.

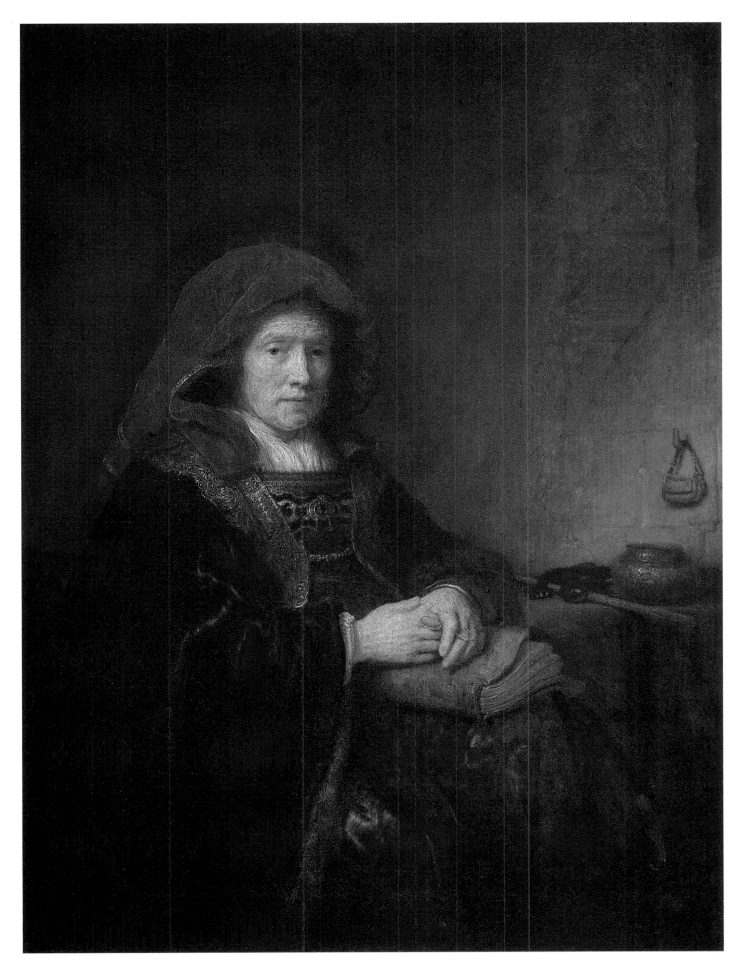

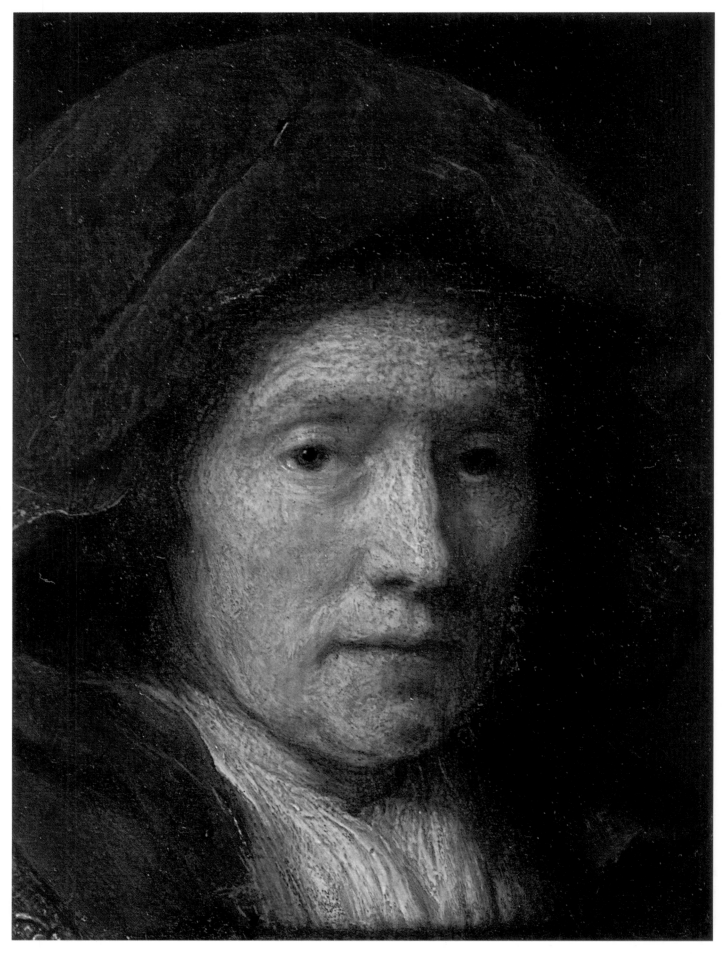

Old Woman in an Armchair. (Detail).

82

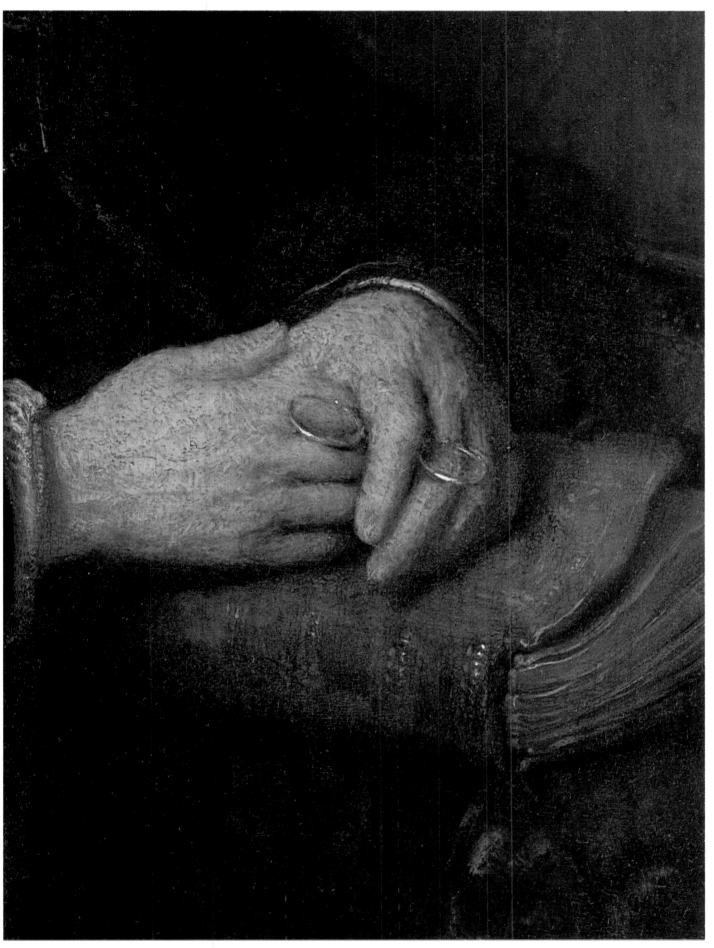

*Old Woman
in an Armchair.*
(Detail).

83

14. PORTRAIT OF AN OLD MAN

Oil on wood (oak); 51 X 42 cm. Enlarged.
Original dimensions of the painting: 47 X 37 cm.
Monogram on the right, above the shoulder:
Rembrandt. f.
St. Petersburg, Hermitage Museum.
Inv. N° 755. Acquired in 1852.

Judging by the fine cracks in the painting, this work was enlarged to its present dimensions and repainted as early as the 18th century. However, since the model's face has remained practically intact, it is not only possible to fully appreciate the artist's skill, but also to establish, with a large degree of certainty, that the work was completed in 1643. The portraiture of elderly people always attracted the master, and if in the 1630s his main concern was to capture the facial structure and expression of his models, ten years later, he was mainly interested in revealing their great nobility of spirit. This portrait of *An Old Man* is a typical example of the second period. The man's wistful gaze and the pained expression on his face are underlined by the gesture of his right hand, placed by his heart; yet this gesture reveals nothing which is not already apparent in the intensity of the man's expression.

Three copies of this work, which were in all likelihood used as exercises for his students, were completed in the master's studio.

85

15. THE HOLY FAMILY WITH ANGELS

Oil on canvas; restretched. 117 X 91 cm.
Signed and dated at the bottom to the left:
Rembrandt. f. 1645.
St. Petersburg, Hermitage Museum.
Inv. N° 741. Acquired in 1772.

Rembrandt's *Holy Family with Angels* strongly resembles a genre scene, but differs from all the contemporary genre paintings found in Holland by its lyricism and poetry. The theme of motherly love, which has always been dear to artists, displays in Rembrandt's work not only a fundamentally human truth, but also a sublime and penetrating quality.

Studies from nature preceded the creation of the Hermitage painting. It is not impossible that it was Hendrickj Stoffels who modelled for this work, even before she became his companion. Three drawings are definitely linked to the Hermitage painting. The first, a rough draught for the painting, shows the Holy Family asleep; dated 1645, the drawing is contemporary with a painting on the same theme inventoried in a private collection in Berlin. A second drawing, which is more a rough sketch of a composition, is in the Bonnat Museum in Bayonne (France). The third is an inverted depiction of the Hermitage scene.

Two borders, measuring 2.5 cm in width in the upper half of the painting and 1.5 cm in the lower part, were added at a later date. Modifications are visible in various parts of the painting, but particularly on the background and on Joseph and Mary's clothes. Corrections carried out by Rembrandt are also apparent on the Virgin's neck and veil.

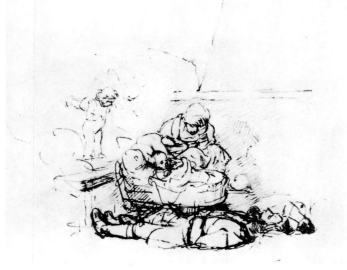

The Holy Family asleep. Circa 1645. Drawing.
L. Clark Collection, Cambridge (Mass).

Child in a Cradle. Circa 1645. Drawing.
Unknown location.

The Holy Family in the carpenter's workshop.
Circa 1645. Drawing.
Bonnat Museum, Bayonne.

86

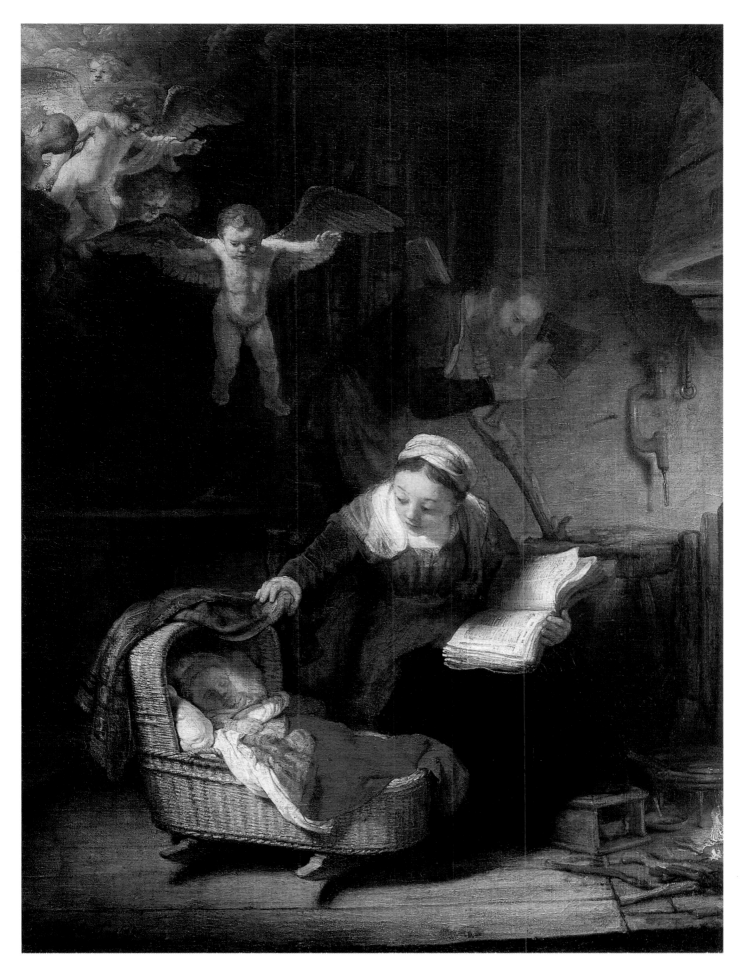

The Holy Family. (Detail).

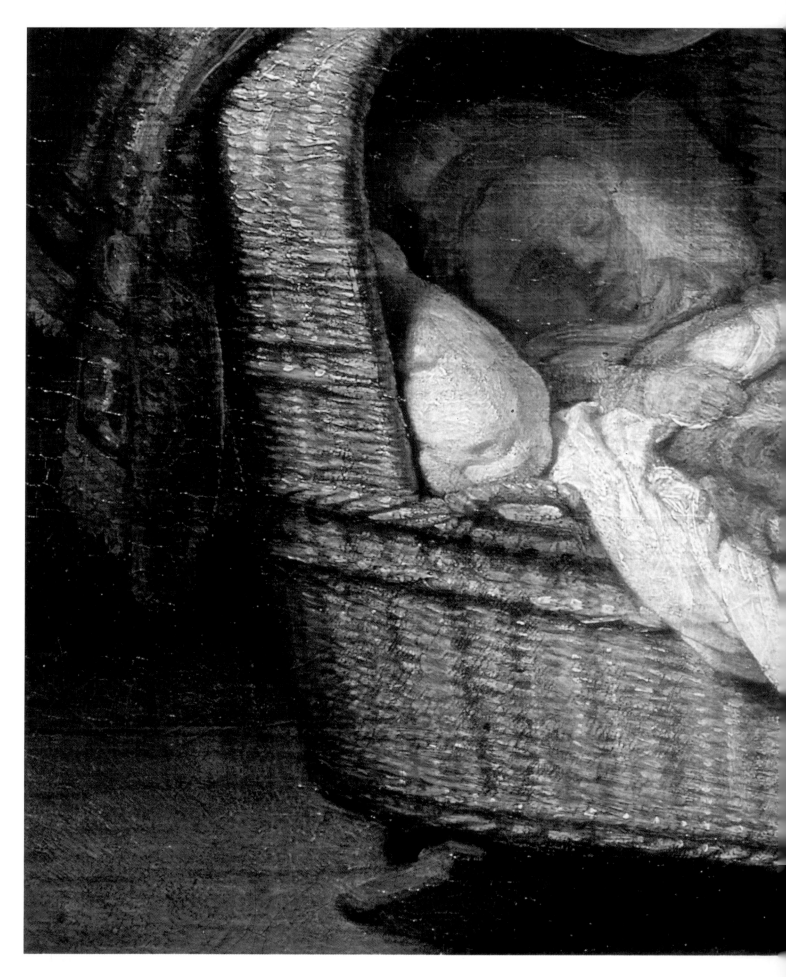

90

The Holy Family. (Detail).

The Holy Family. (Detail).

92

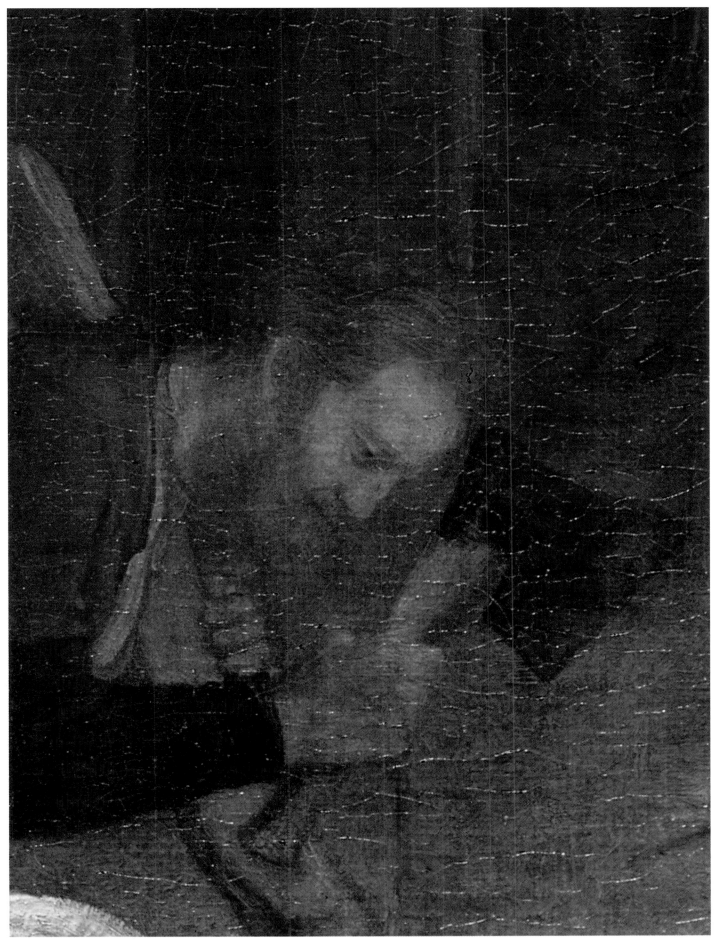

*The Holy
Family.*
(Detail).

93

16. DANAÉ

Oil on canvas; new canvas backing. 185 x 203 cm.
Signed and dated to the left at the bottom
(date almost illegible): Rembrandt. f. .6.6.
St. Petersburg, Hermitage Museum.
Inv. N° 723. Acquired in 1772.

Danaë's legend often inspired artists: Acrisios,
king of Argos, had his daughter locked in a tower
as it had been predicted that he would die at the
hands of his grandson. Zeus, having fallen in love
with Danaë, changed himself into golden rain in
order to penetrate the tower. This mythological
rain, an essential symbol in the depictions of
this scene, is curiously absent in Rembrandt's
work, and for a long time led to doubts being
cast as to the identification of the subject-matter.
Eleven different theories concerning this problem
succeeded each other until the 1960s, when
technological and stylistic analysis confirmed
the Danaë thesis definitively.
The data supplied by x-ray analysis also showed
that the painting had been created at two separate
times. An initial version, dating from 1636 was
restarted ten years later and probably reworked
by the artist himself. Five major changes to the
composition involving the right hand and arm
of the young girl, her features and her hair style,
as well as the position of her right leg have
been detected by experts as well as minor changes
involving the artist's technique, which had
improved over the ten-year interval. He also
changed the position of the old serving-woman in
the middle ground and removed a little heap of
pearls which were on the table, leaving the string
of the pearls visible on the tablecloth.
Rembrandt's full freedom of expression is evident
in this version of the painting, which undoubtedly
remains as one of the masterpieces of his mature
years as an artist.

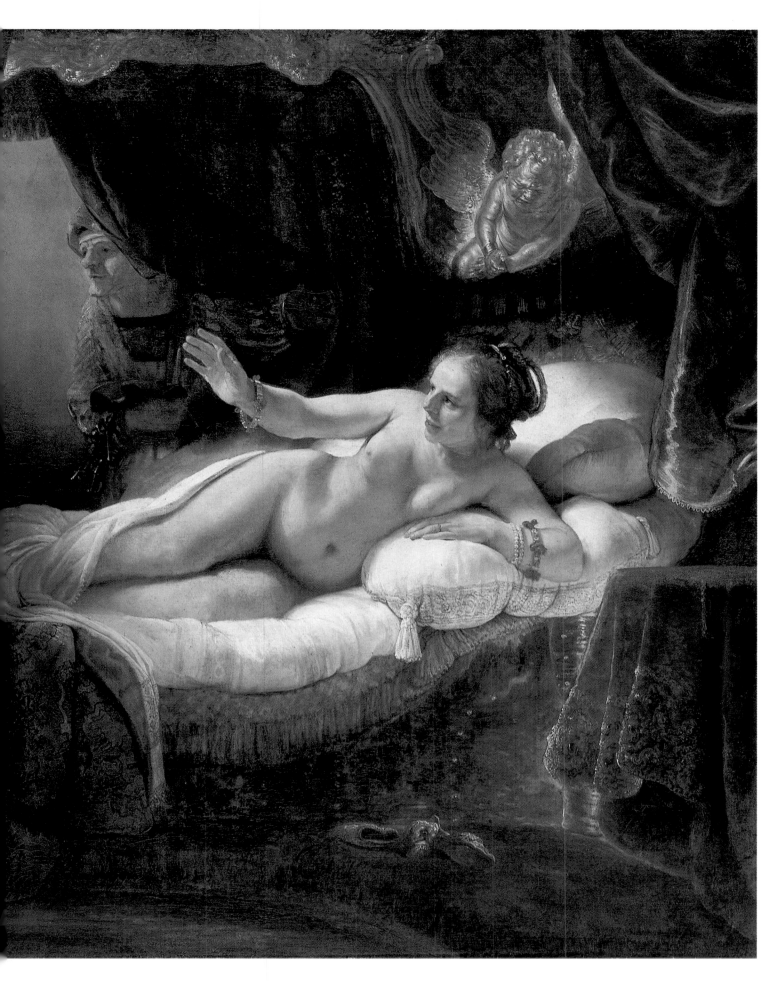

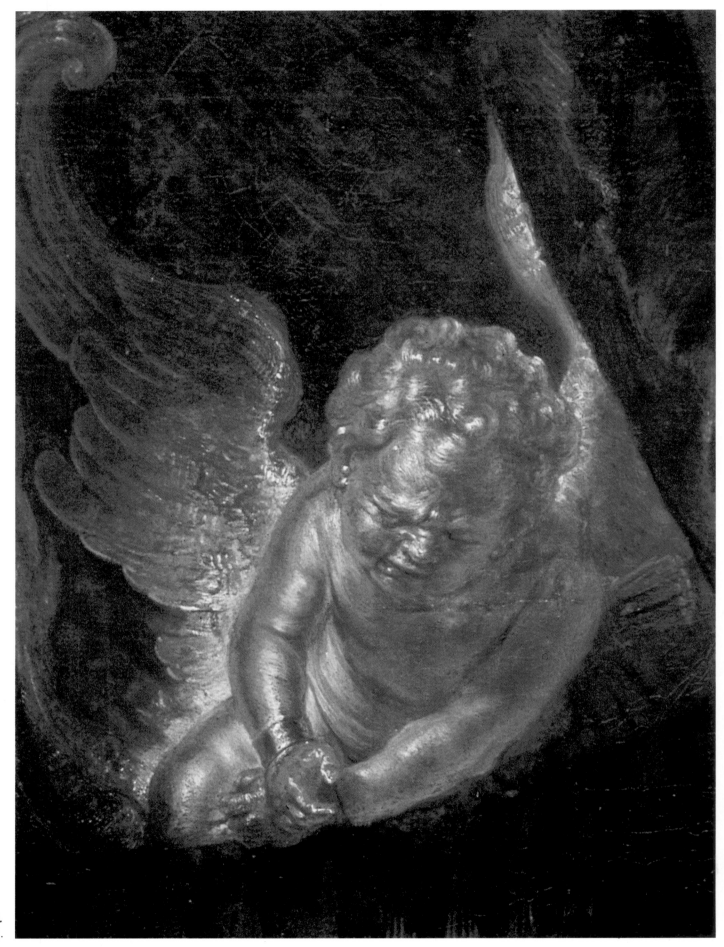

Danaë.
(Detail).

96

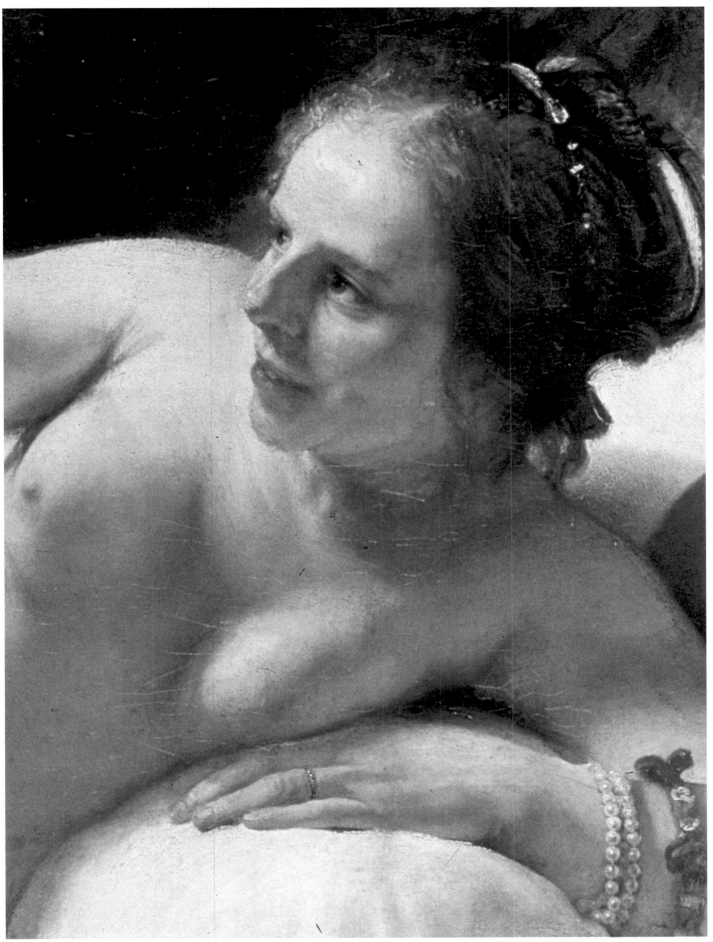

Danaë.
(Detail).

97

Danaë.
(Detail).

Danaë.
(Detail).

100

Danaë.
(Detail).

101

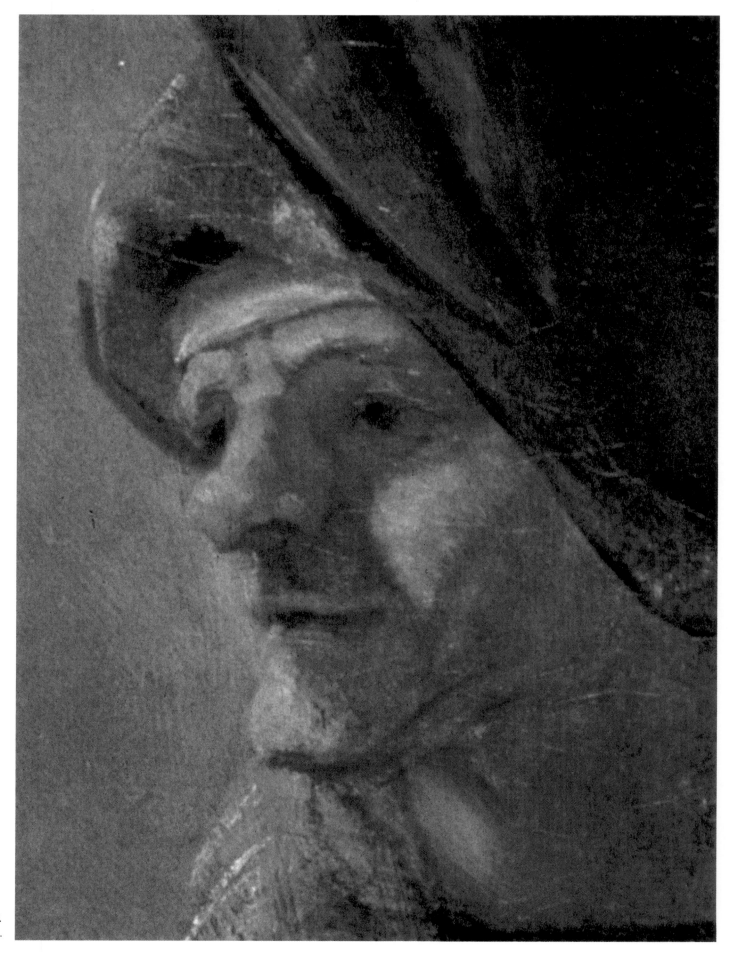

Danaë.
(Detail).

Danaë.
(Detail).

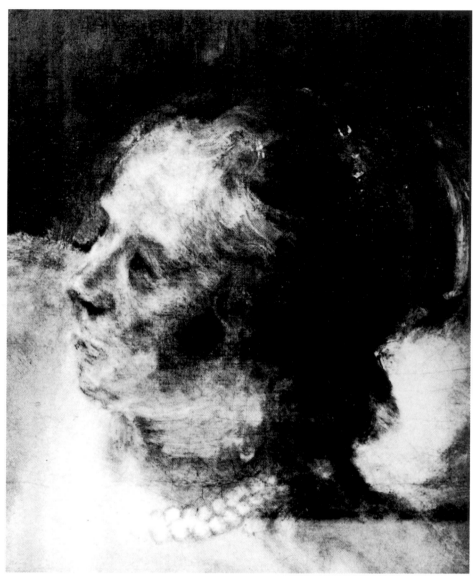

Danaë. Head (x-ray plate).
Hermitage Museum, St. Petersburg.

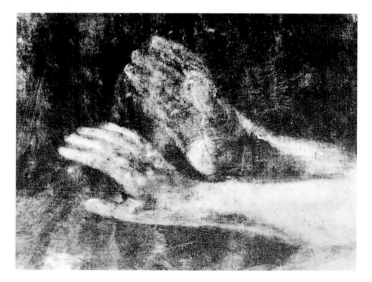

Danaë. Right hand (x-ray plate)
Hermitage Museum, St. Petersburg.

Danaë. Left hand (x-ray plate).
Hermitage Museum, St. Petersburg.

104

Danaë. The Old Servant (x-ray plate).
Hermitage Museum, St. Petersburg.

Danaë. Table (x-ray plate).
Hermitage Museum, St. Petersburg.

Danaë. Love (x-ray plate).
Hermitage Museum, St. Petersburg.

Danaë. Knee (x-ray plate).
Hermitage Museum, St. Petersburg.

17. PORTRAIT OF AN OLD LADY

Oil on canvas. 82 x 72 cm.
Signed and dated on the background to the right:
Rembrandt. f. 16(5)
Moscow; Pushkin Museum.
Inv. N° 2622. Acquired for the Hermitage in 1779
and transferred to the Pushkin Museum in 1930.

The absence of the last figure in the date of completion of the painting leads one to believe that the border of the canvas was cut by at least 6 to 8 cm, and that the work must originally have been practically square. This work, which is distinguished from other portraits of elderly ladies by the referring to it as the *Portrait of a Well Dressed Lady,* conveys an impression of sombre magnificence, whilst the glimmer of the blue sapphire reveals the warm tones of the composition and the model's social status. Yet, at the same time, the figure depicted seems to spring strait from Rembrandt's imagination, since the lady's costume bears no resemblance to the Dutch fashion of the time: delightfully picturesque,

the costume is created wholly by the artist, and calls to mind the "Burgundian" style.

Certain authors would have us believe that the dark veil which features frequently in Rembrandt's work, is the ritual Jewish prayer shawl, the *talith* and that all the models who wear this veil represent biblical prophetesses.

The "objective" character of the model results from the pictorial quality of the painting. Certain areas, such as the face, are painted using superimposed glazing techniques containing little lead white. Taking into account the psychological traits of the model, from the basic composition which has been revealed by means of x-rays and the technique employed by the artist, it is possible to establish that this painting dates from the beginning of the 1650s. This elegant and meticulous painting, which combines grandeur and authenticity, is one of the most important and interesting of Rembrandt's works in the Russian collections.

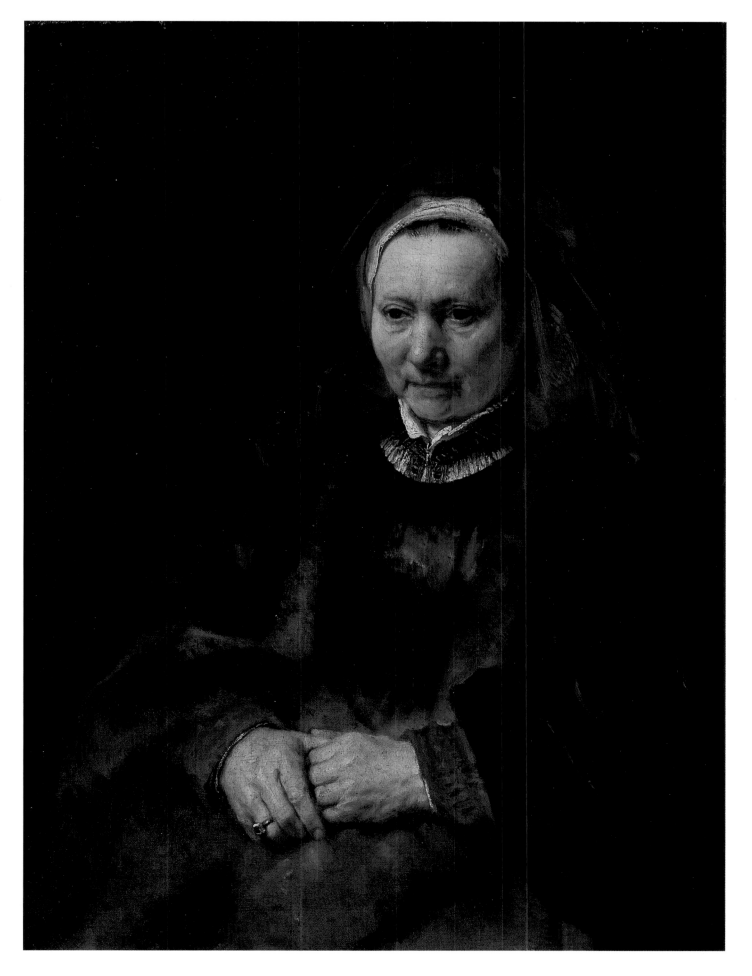

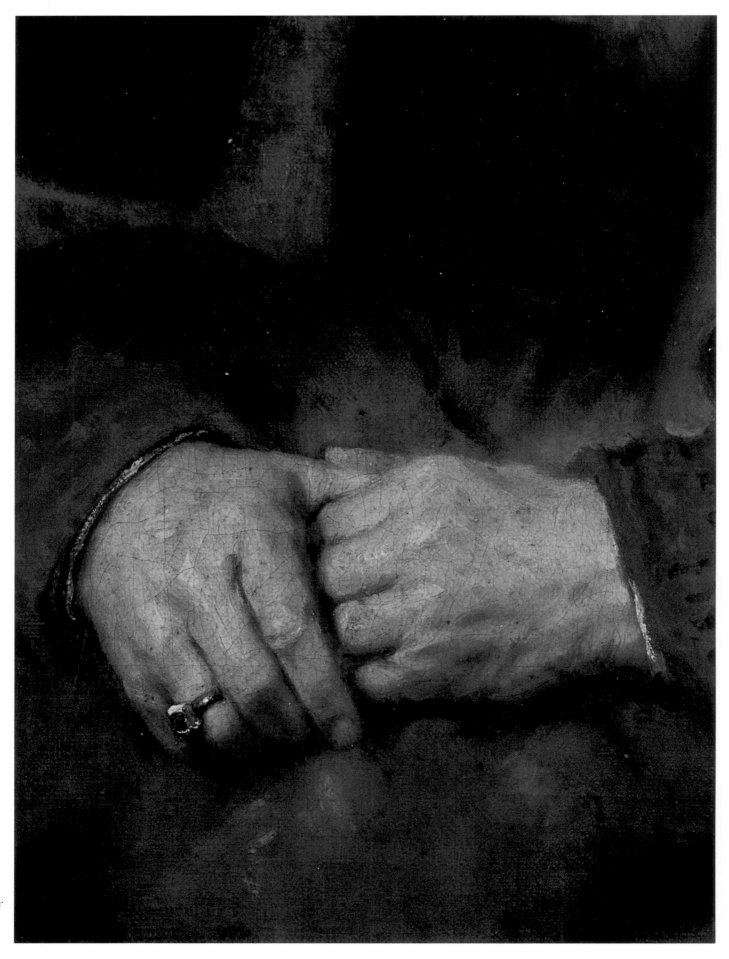

*Portrait of
an Old Lady.*
(Detail).

108

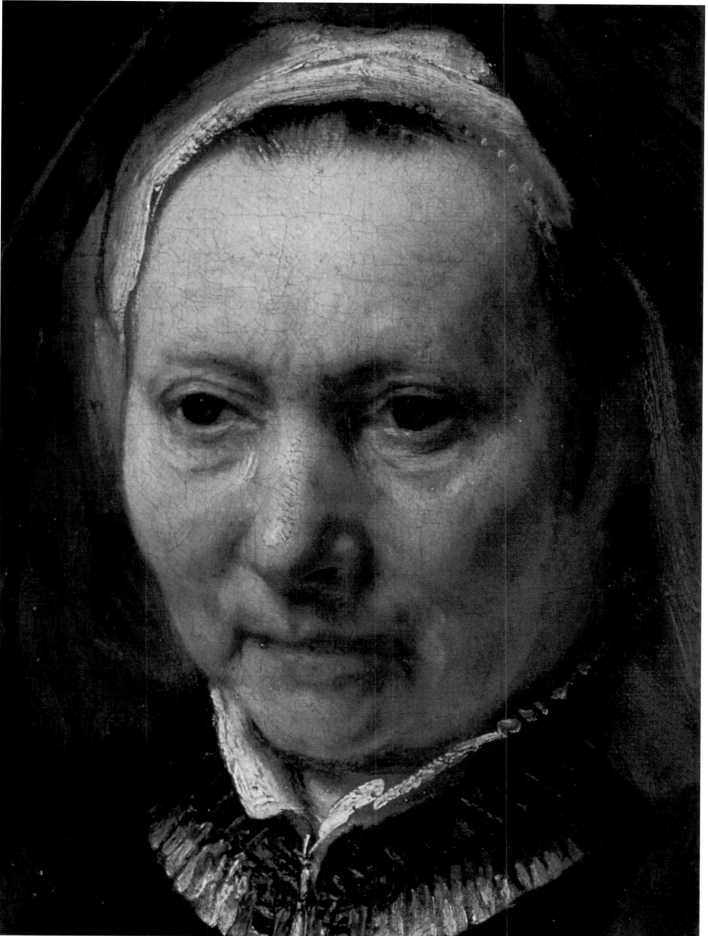

*Portrait of
an Old Lady.*
(Detail).

*Portrait of
an Old Man in
an Armchair.*
(Detail).

112

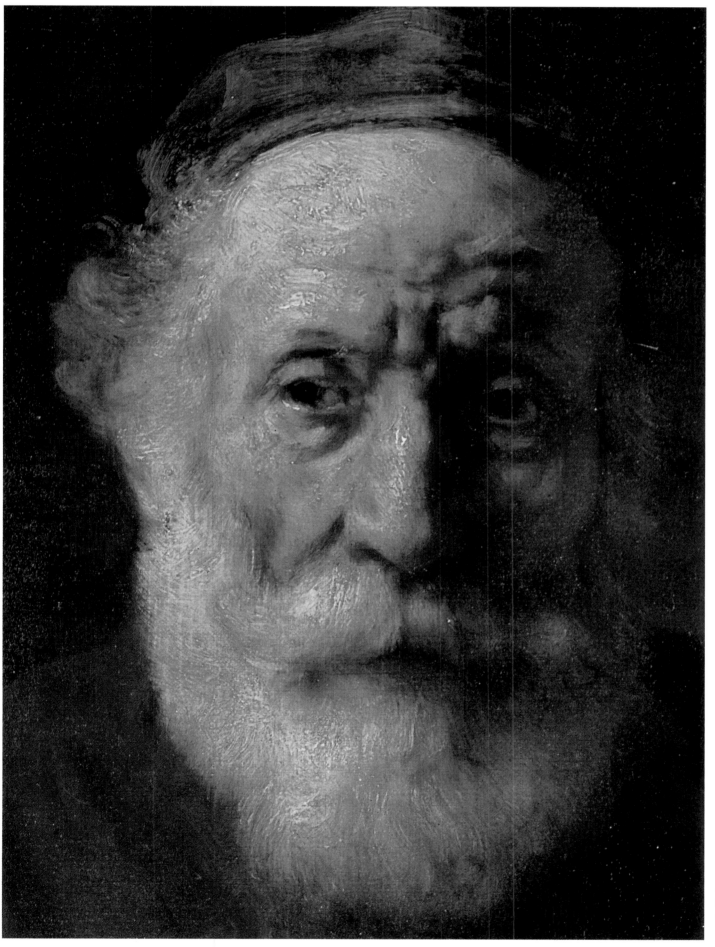

*Portrait of
an Old Man in
an Armchair.*
(Detail).

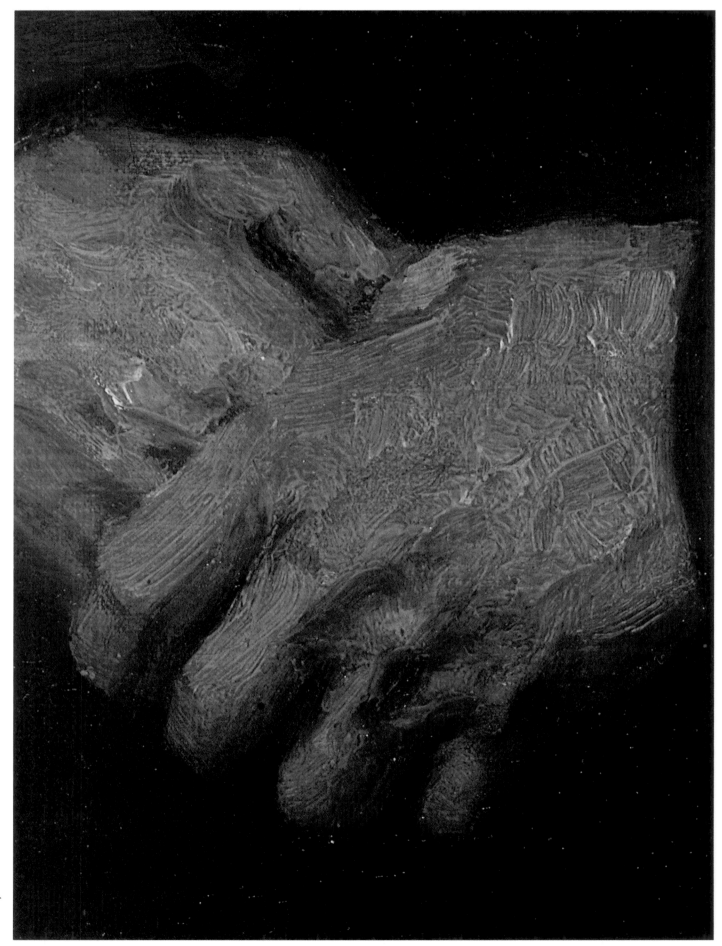

*Portrait of
an Old Jew.*
(Detail).

116

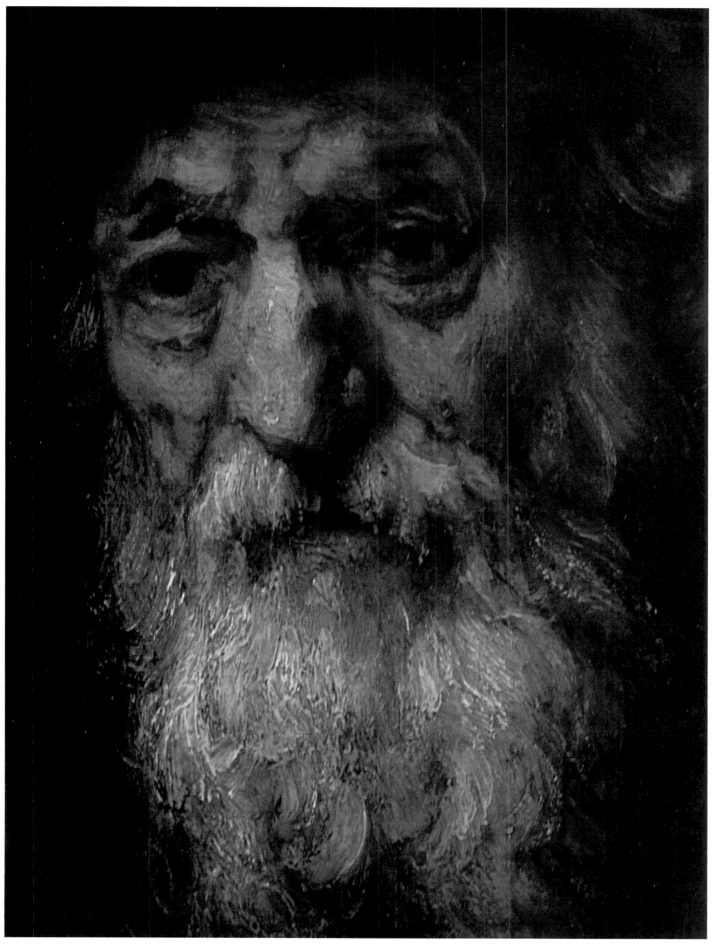

*Portrait of
an Old Jew.*
(Detail).

117

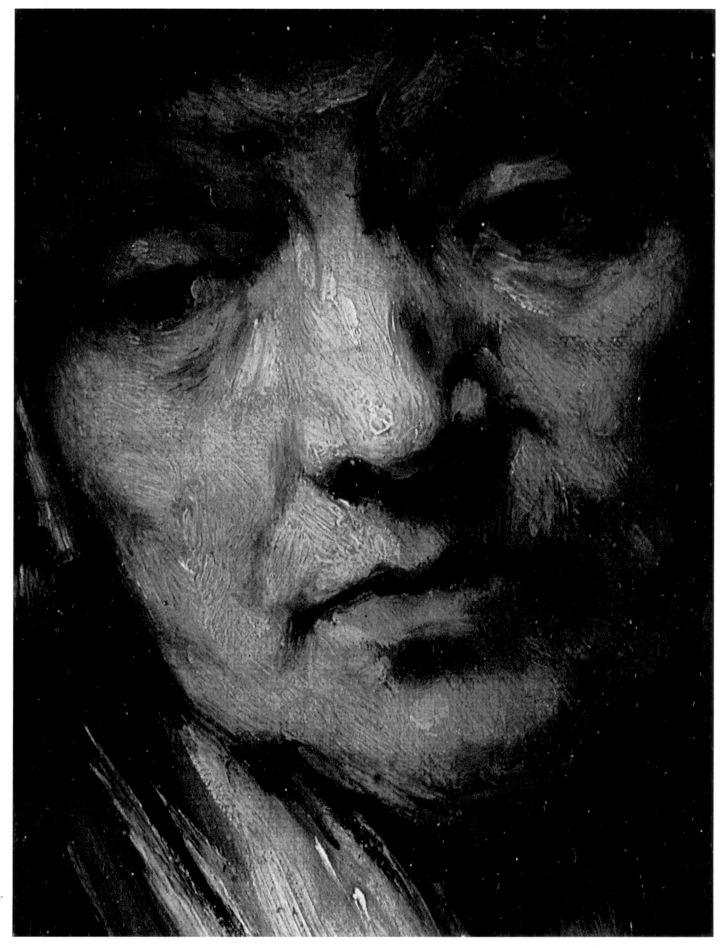

Portrait of an Old Lady. (Detail).

120

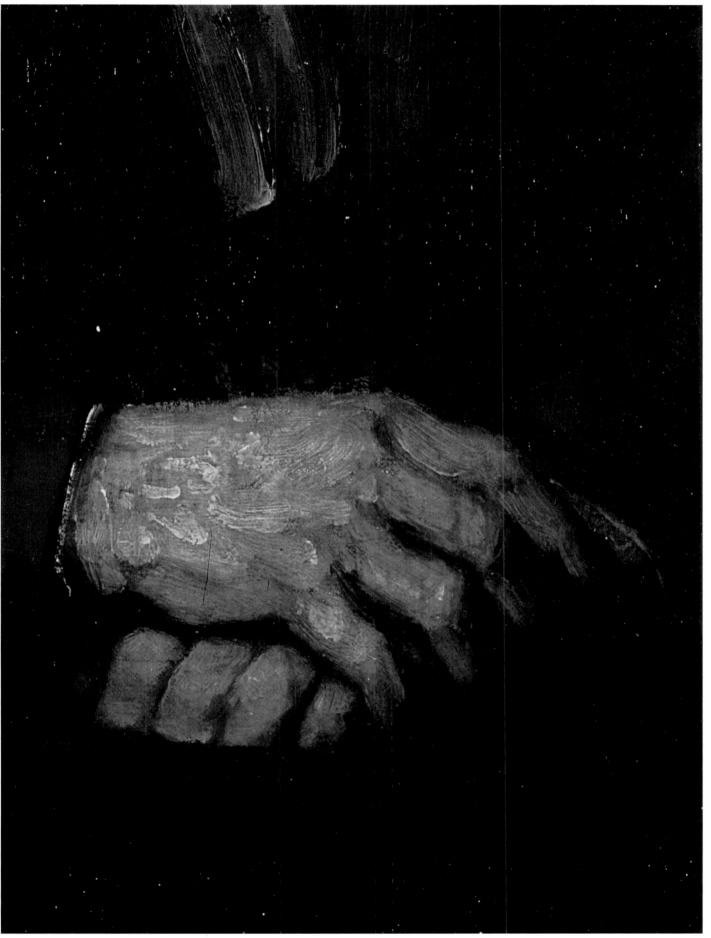

*Portrait of
an Old Lady.*
(Detail).

121

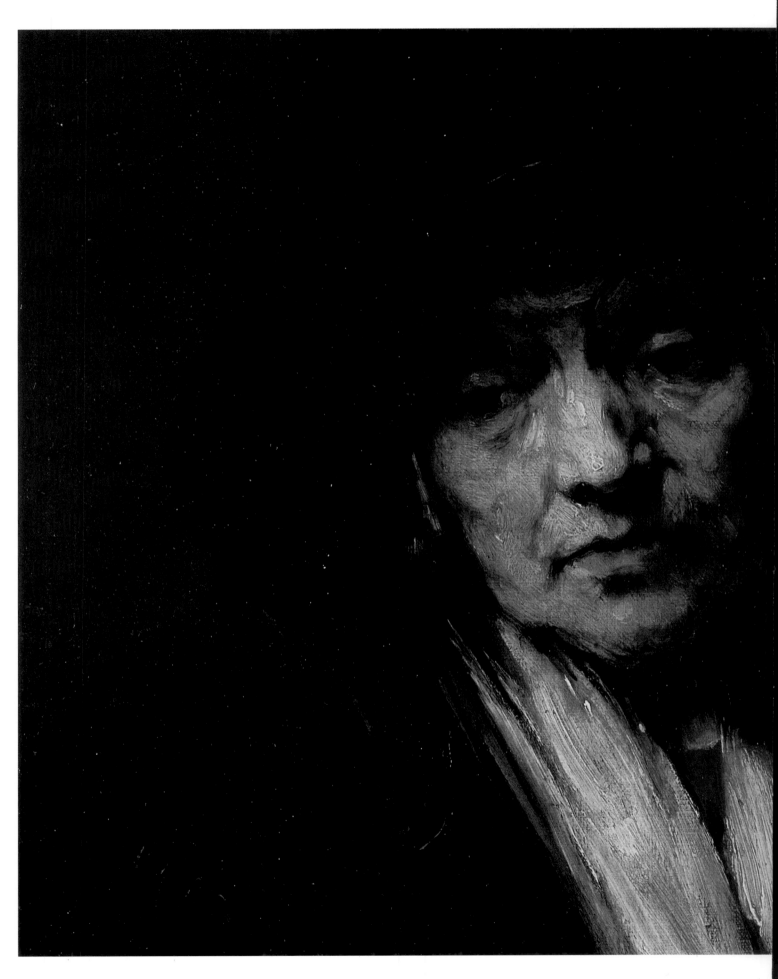

*Portrait of
an Old Lady.*
(Detail).

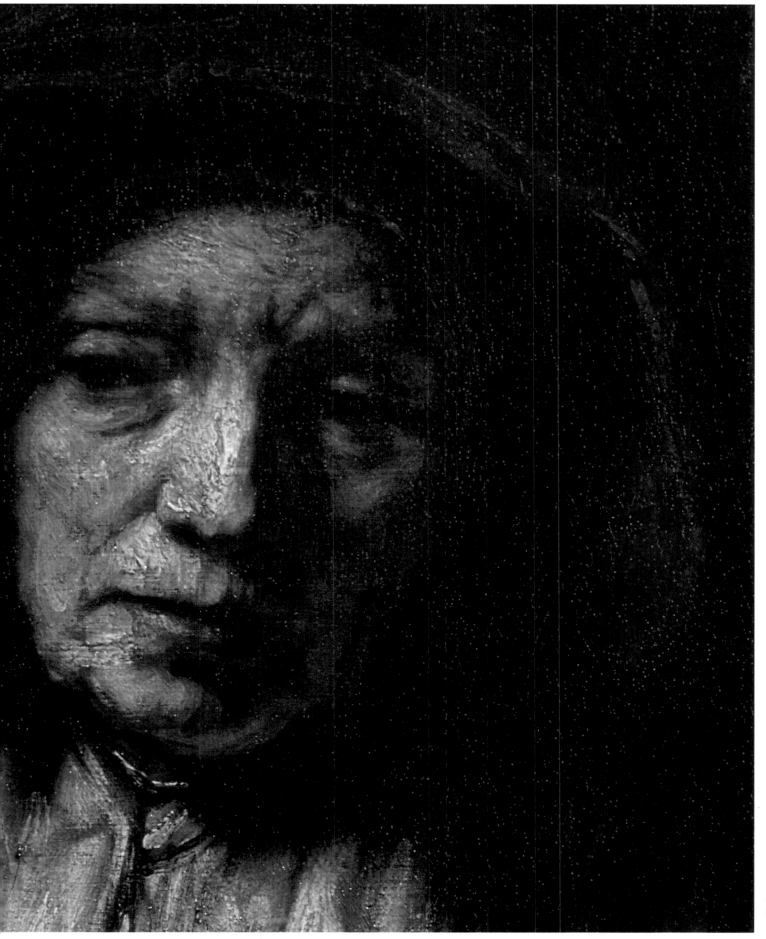

*Portrait of
an Old Lady.*
(Detail).

127

22. PORTRAIT OF ADRIAEN VAN RIJN, THE ARTIST'S BROTHER (?)

Oil on canvas; restretched. 74 x 63 cm.
Signed and dated on the background on the left,
above the shoulder: Rembrandt. f. 1654
(date almost invisible).
Moscow, Pushkin Museum.
Inv. N° 2627. Acquired by the Hermitage in 1769,
transferred to the Pushkin Museum in 1930.

It would seem, nowadays, that Adriaen van Rijn was one of his brother's favourite models: a number of portraits of him were created in the 1650's, and among the most famous is the figure of the *Man with the Golden Helmet*. According to the little information we have from archives, Adriaen was a cobbler, and lived Leyden throughout his lifetime. He inherited his father's mill in 1639 and died around 1651-1652. These dates cast doubt over the identity of the man figuring in the Moscow portrait (1654) and fuel the argument of the detractors of this thesis, but in the absence of certainty, it is possible to imagine that Rembrandt painted his brother from memory, as he painted Saskia and his mother. The Moscow portrait is distinguished by an extraordinary sense of spontaneity. Allowing himself to be carried along by the visual impressions, the artist seems to have had no other concern than to fully render the subtle play of reflections on the features of the man, submerged in a scintillating half-light. The face is sculpted with short, free strokes, employing different hues, yet of a similar tone.

Not wholly satisfied with his work, the artist later modified a few details. Originally, there was indeed a thick white band along the collar, which the artist repainted nearly completely using a black glaze; The relief created by the thickness of the white band is clearly visible under the painted surface. This band and the white highlights which continue under the paint are particularly clear in the x-ray plate. In all probability the model was originally wearing a white shirt. Too striking to Rembrandt's taste, this was replaced in order to unify the tones of the composition and maintain the harmony of the chiaroscuro. The painting was undoubtedly carried out whilst the paint was still wet, which led to the formation of the fine cracks in the black glaze. Other minor modifications were equally made to the beret, to strengthen the order of the composition and find a measured harmony between the figure of the elderly man and the surrounding paint.

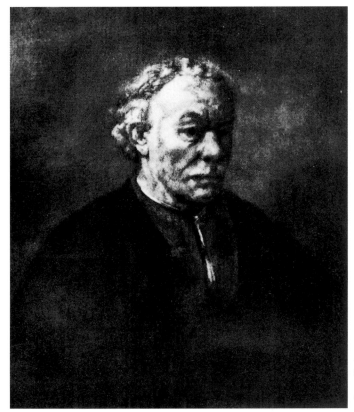

Portrait of Adriaen van Rijn.
1650. Mauritshuis, The Hague.

128

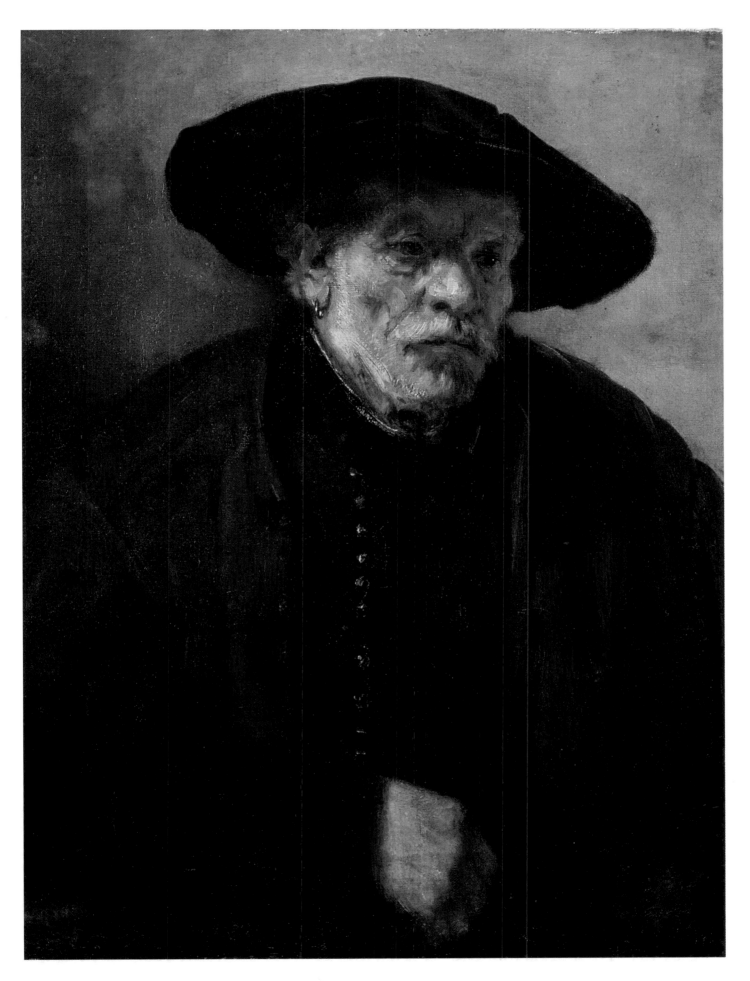

129

130

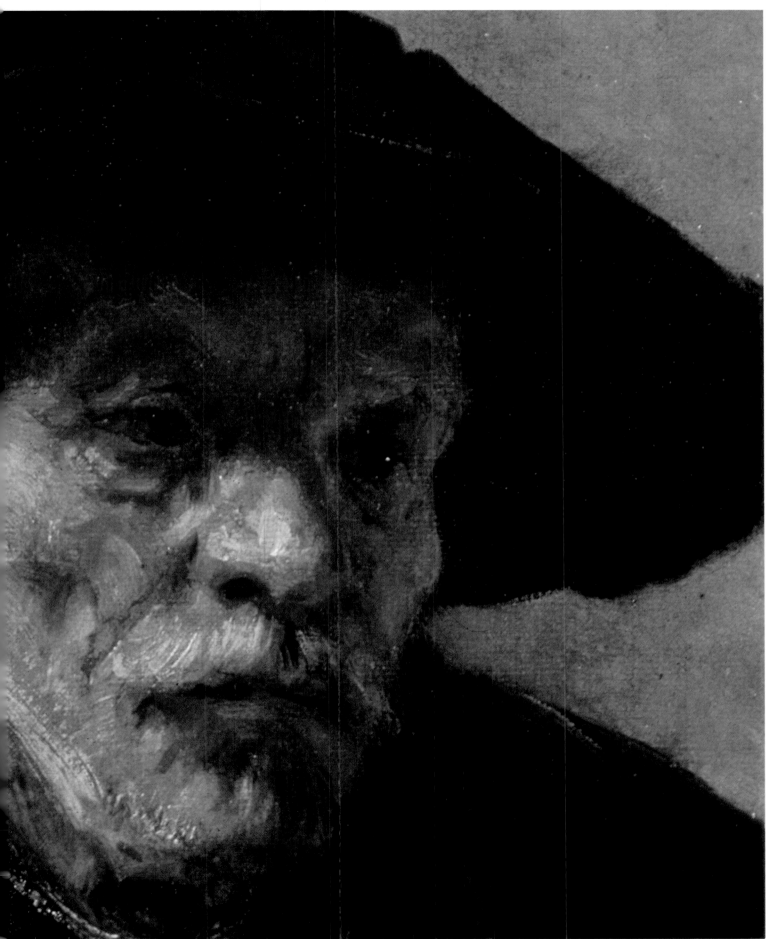

*Portrait
of Adriaen
van Rijn.*
(Detail).

131

23. YOUNG LADY TRYING ON EARRINGS

Oil on wood; reinforced. 39.5 x 32.5 cm.
Added upper corners: on the left, a triangle
with sides measuring 9.5 and 4.5 cm;
on the right another triangle
with sides measuring 9.5 and 4.3 cm;
at the bottom a band added later,
with a width of 7.2 cm.
Signed and dated on the left, on the casket:
Rembrandt. f. 1657.
St. Petersburg, Hermitage Museum.
Inv. N° 784. Acquired in 1781.

It is generally accepted that Henrickje Stoffels
was Rembrandt's model for this painting,
although it is difficult to find much resemblance.
The theme of Vanity, dear to the artist, was not
recent: numerous studies prove that his interest
was long standing, as Saskia, in the 1630s
already, was a model for this theme. According
to certain specialists, the Hermitage painting is a
partial copy made by Rembrandt of Saskia's
portrait currently held at Buckingham Palace;
others have considered it to be a fragment of
a much larger composition, even possibly – in
spite of its late dating – the Courtesan combing
her hair, mentioned in the inventory of the artist's
belongings.

Originally, the panel on which the scene is painted
was octagonal; but when the lower panel, approxi-
mately the same size as the current addition,
was lost then restored (without the chopped off
corners), the upper corners also made their
appearance. Restorations to cover the joints in the
wood now mask part of the original painting.

Saskia (?) in front of a mirror. 1630s. Drawing.
Musée Royal des Beaux-Arts, Brussels.

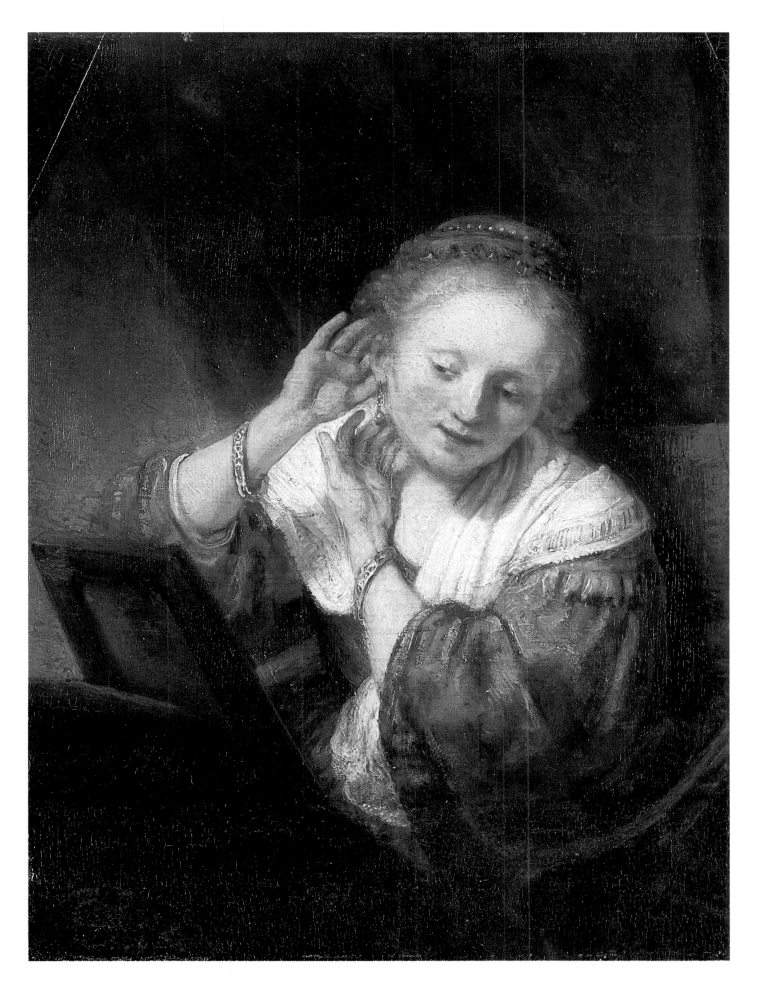

133

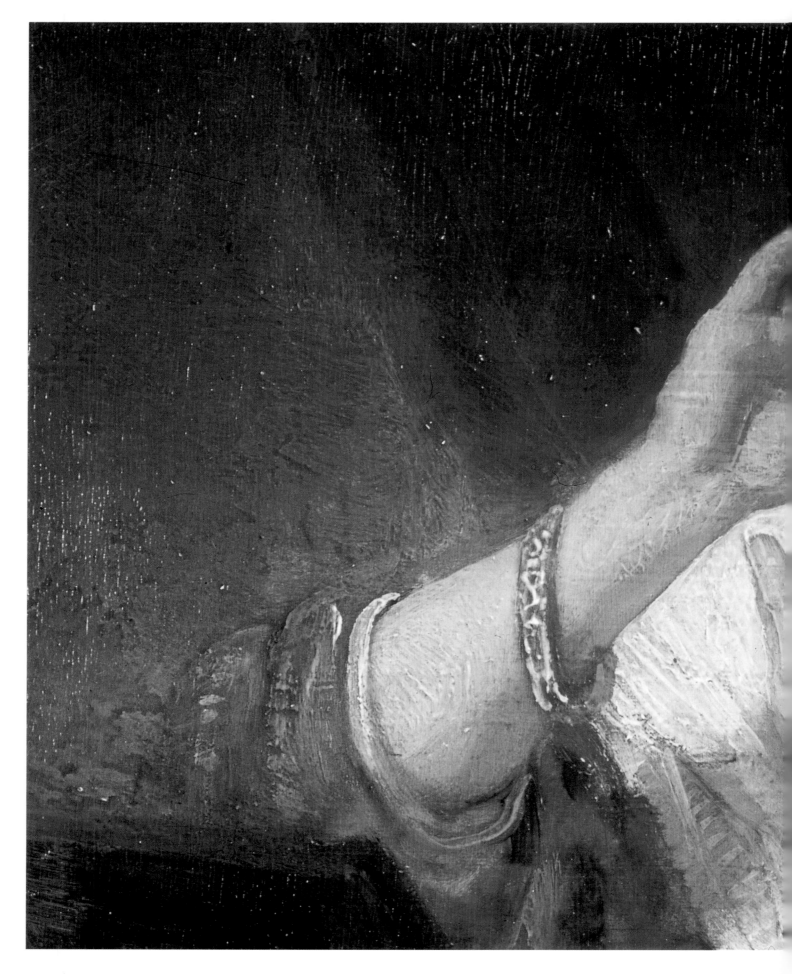

134

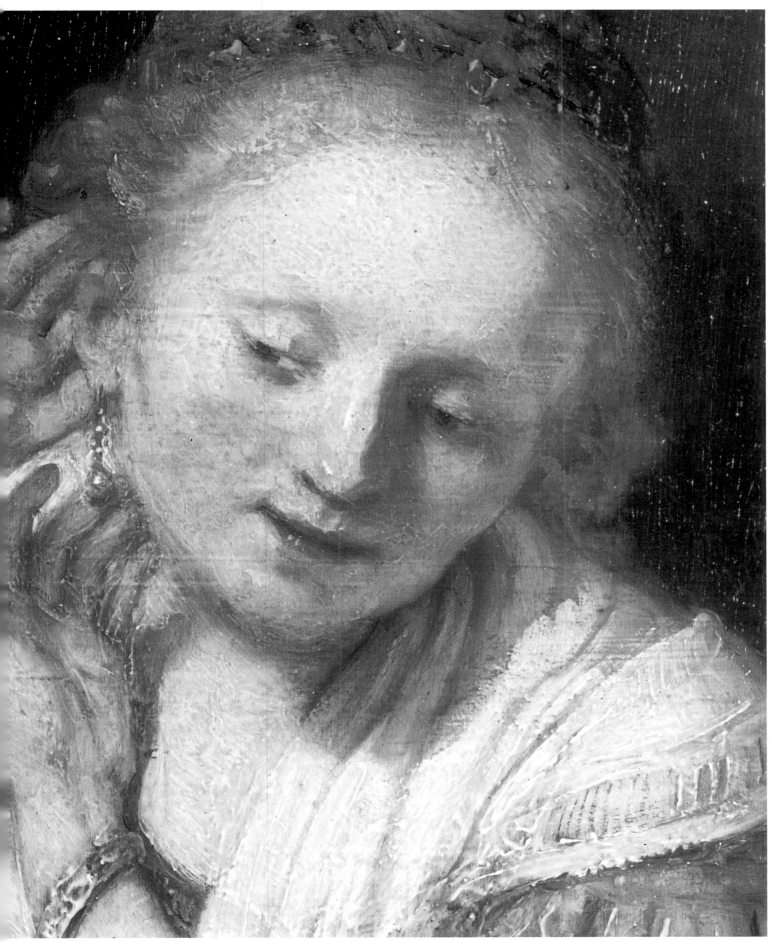

*Young Lady
trying
on earrings.*
(Detail).

135

24. CHRIST AND THE SAMARITAN WOMAN

Oil on canvas; restretched. 60 x 75 cm.
Signed and dated on the well:
Rembrandt. f. 1659. Restored.
The signature is authentic.
St. Petersburg, Hermitage Museum.
Inv. N° 714. Bought in 1780
for the Potemkin collection,
acquired for the Hermitage in 1792
the painting was returned to the Museum in 1898 after
having been transferred to the collections in Catherine's
palace.

The Hermitage version is the last and most important in a whole series of works which strongly attracted Rembrandt in the 1650s. We are most familiar with two of them, dating from 1655, and kept respectively in the Dahlem Museum in Berlin and in the Metropolitan Museum of Art in New York.
The bad state of preservation of this painting, which for a long time led to doubts as to its authenticity, impedes the full appreciation of the original pictorial quality. We can however, judge the perfection of the composition, and the profound emotional character of the work, concealed beneath an apparent reserve. Marked by a strong spirituality, the artist seems indeed to have sought to illustrate Christ's words to the sinner: "The hour is close when you will adore the father neither on this mountain nor in Jerusalem." Wearied by the heat and the path, Jesus spoke to her of the "live water" that gave faith whilst the Samaritan, meanwhile, offered him water from the well.

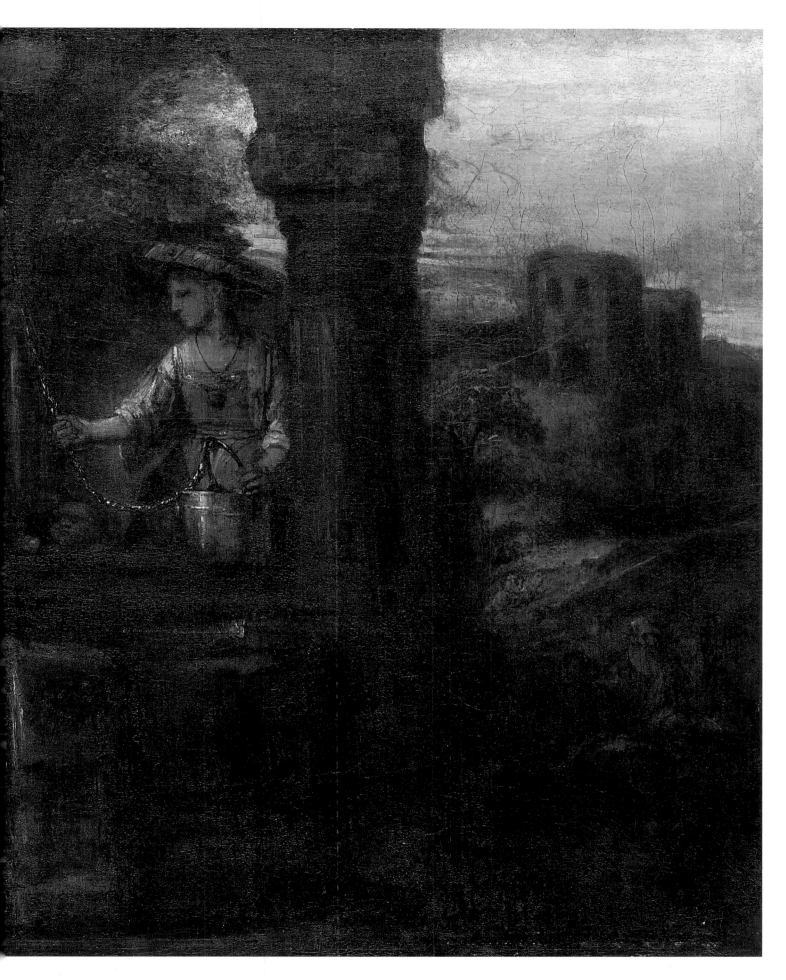

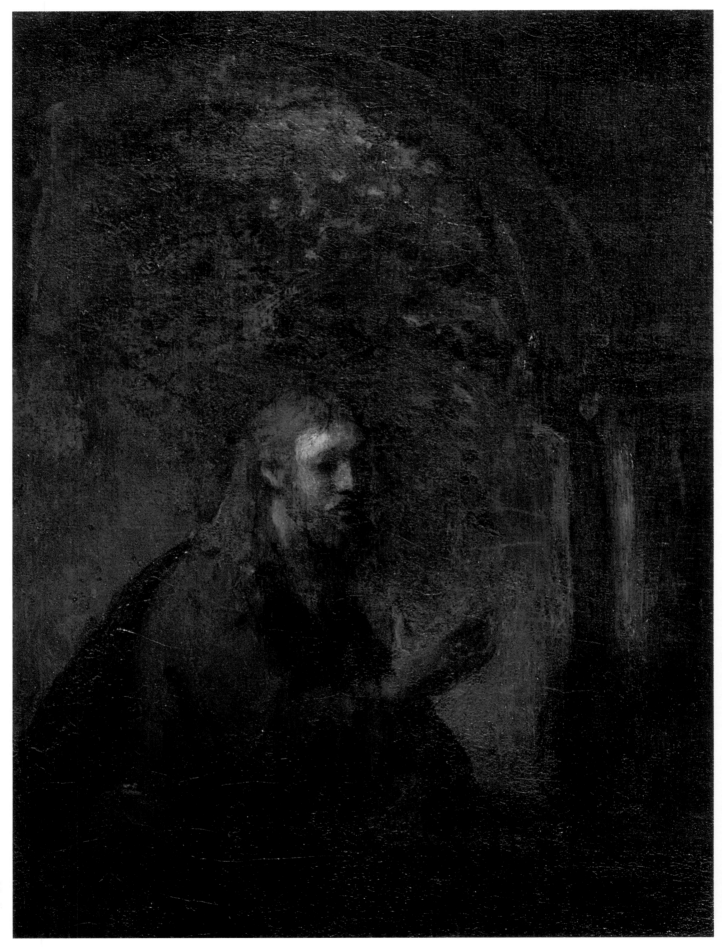

Christ and the Samaritan Woman. (Detail).

138

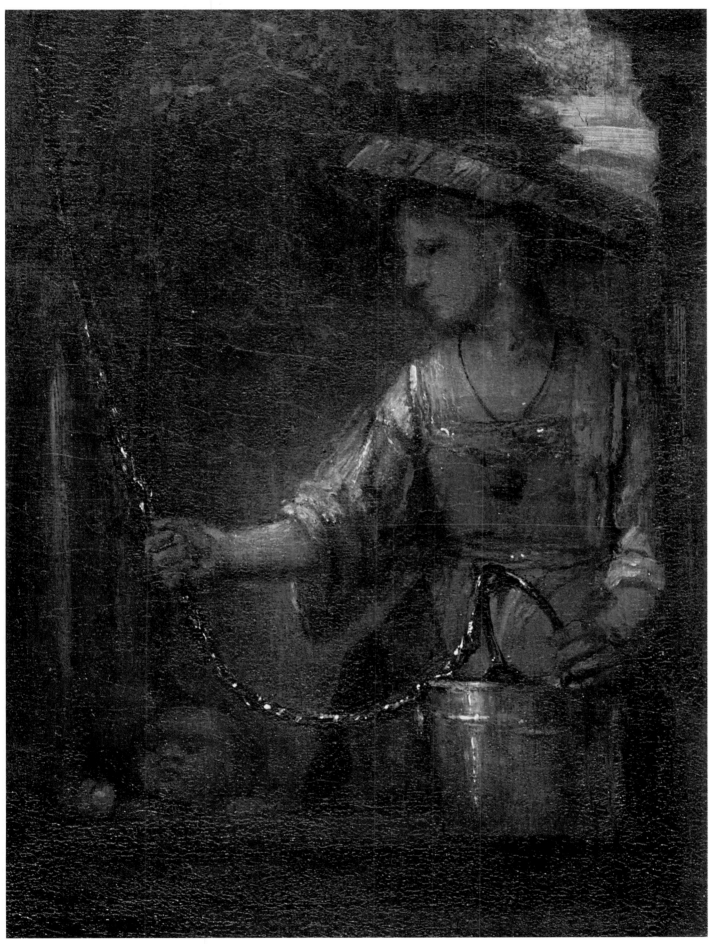

Christid and
the Samaritan
Woman.
(Detail).

*Christ and
the Samaritan
Woman.*
(Detail).

140

Christ and the Samaritan Woman. (Detail).

141

25. HAMAN AND AHASUERUS
AT THE FEAST OF ESTHER

Oil on canvas; restretched. 73 x 94 cm.
Signed and dated at the bottom, in the left-hand corner:
Rembrandt. f. 1660.
Moscow, Pushkin Museum.
Inv. N° 297.
Acquired for the Hermitage in 1764,
given to the Roumiantsev Museum in Moscow in 1862
then given to the Pushkin Museum in 1924.

The tragic story of Queen Esther, who was Jewish
and poisoned her husband the King of Persia, as
well as her favourite, in order to save her people
from the King's wrath, was very popular with
artists in the 18th century. Beyond the realm of
the symbolical, the theme served as a pretext for
depicting a magnificent banquet, the astonishment
and fury of the King, Esther's triumph and
Haman's terror. Moreover, Rembrandt's contemp-
oraries saw in the painting a quality which they
expected from it: a sense of pathos.
Leaning slightly forward, Haman and Esther seem
on the verge of complying with the King's will;
their movement seemingly prolonged in their gaze.
No outward sign reveals that they are adversaries,
as their battle is entirely on a spiritual plain.
The King, thoughtful, looks straight ahead.

The Emperor Jahangir receiving a supplicant.
1650s. Drawing. British Museum, London.

142

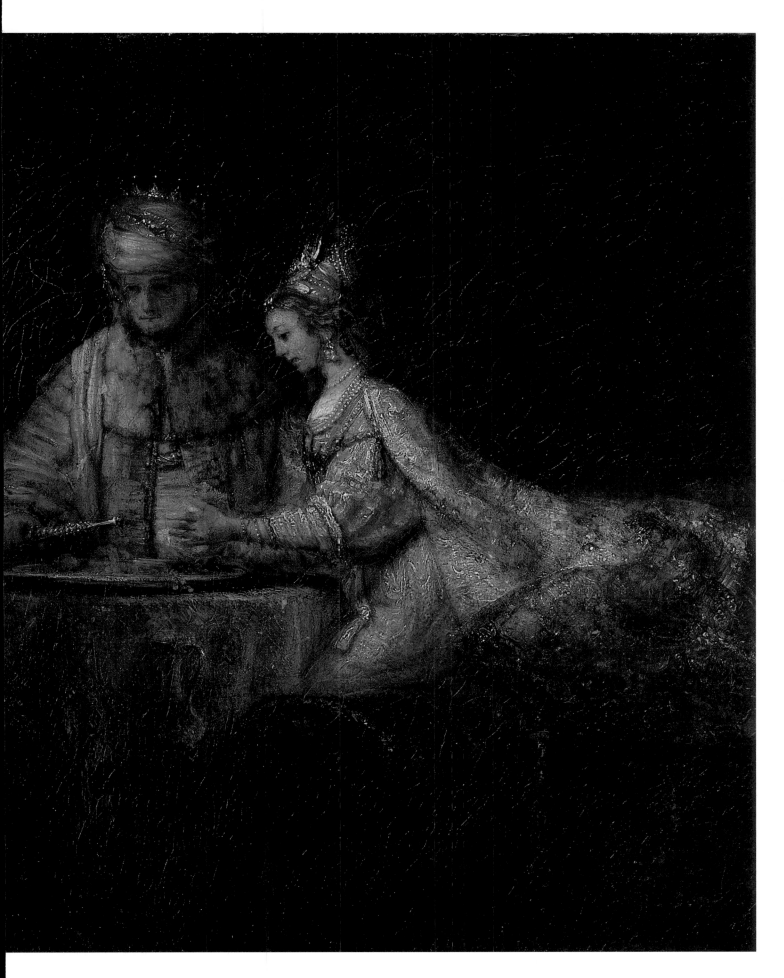

143

One feels that he is less preoccupied with the fate of his two guests than with thoughts of the paths of good and evil, of lies and truth which inhabit men's hearts. In stead of a biblical illustration, Rembrandt seems to have created a work concerned with the meaning of life. Esther, who has just revealed her act to the King, places herself at his mercy, whilst Haman, felled and palpitating, holds his cup unconsciously in his hands. The characters' gestures and poses are far more revealing than their faces.

According to Rembrandt, the visual impact created by a painting is determined by the correlation existing between the central, lit part of the canvas, and the surrounding space. It is unfortunately only very rarely that one may appreciate this, as such a display requires very strong lighting, as is enjoyed by this painting. Progressively, after the eye has adjusted to the brightness of the central subject of the work, one comes to uncover, in the midst of the surrounding shadows, the "worrying" red-brown glaze of the composition.

Unlike many other of the artist's works, we know the names of all of the painting's owners up to its acquisition by the Hermitage in 1664. Similarly, we know that the painting was badly damaged when it arrived in Russia, that it was restretched in 1819 and that a new canvas was stuck on the back of the original ten years later. In 1900, the painting was restored, glued to a new canvas for a second time, and then a third time in 1930. Currently, there are a number of deep cracks and bubbles on the canvas.

On closer examination, it is possible to see that the painting has been restored and repainted at different times. The state of the canvas makes it difficult to fully appreciate the artist's work, but the painting remains nonetheless one of his greatest accomplishments.

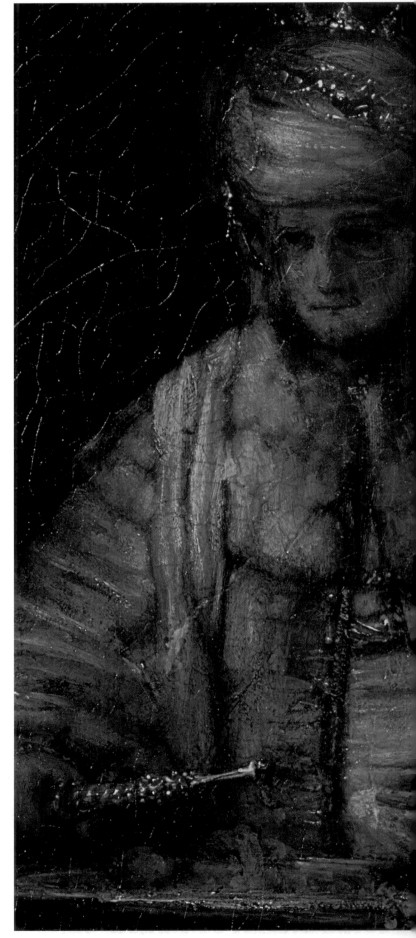

144

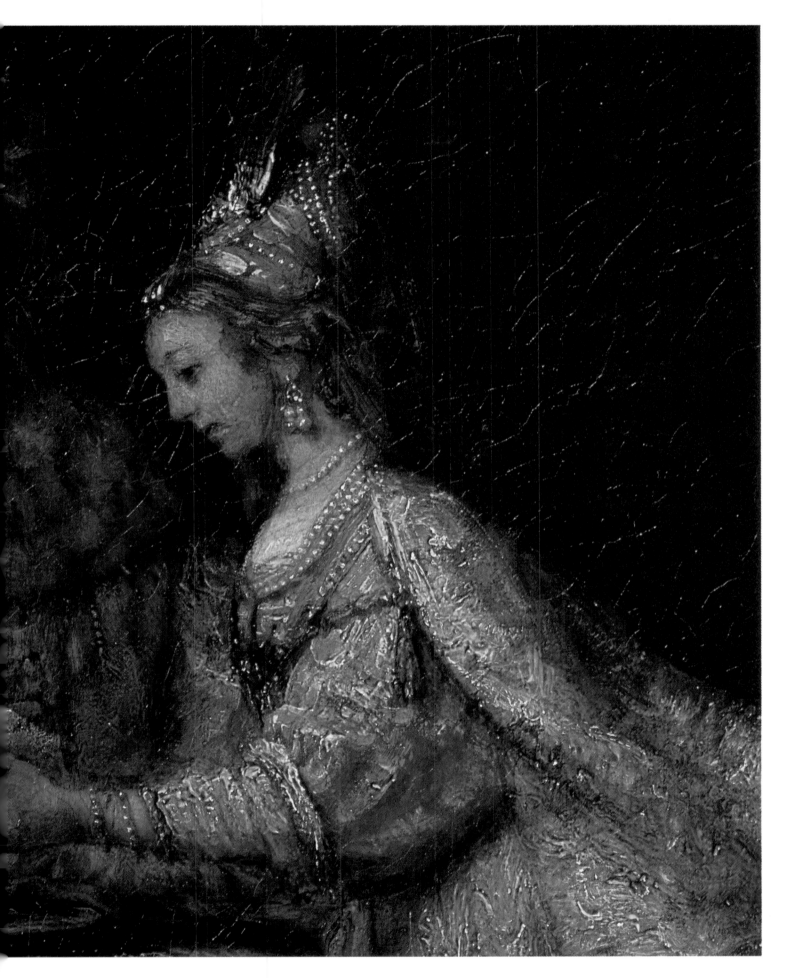

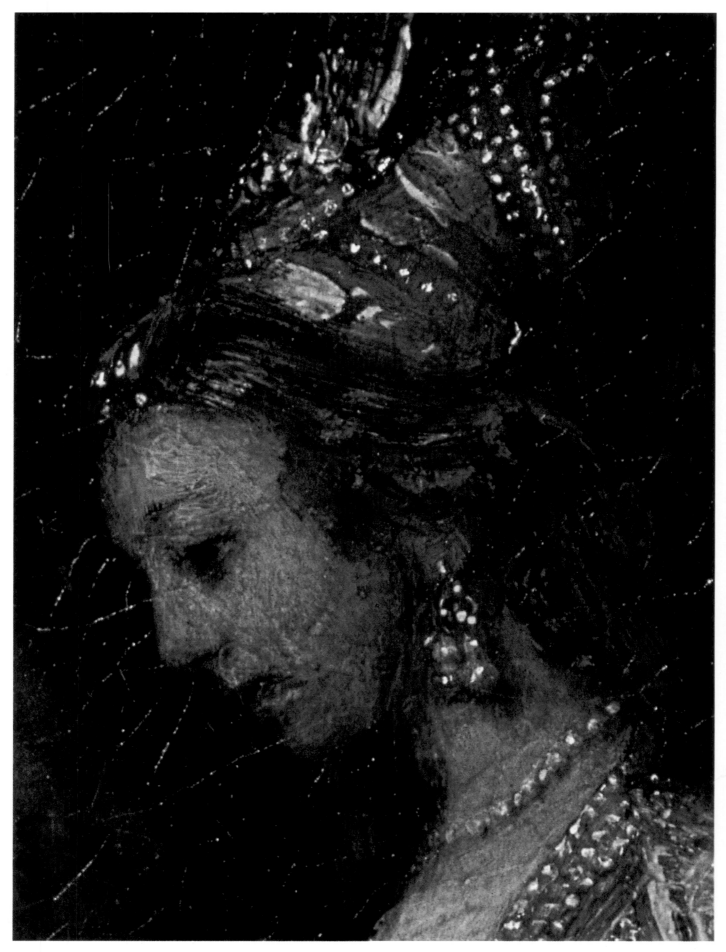

*Haman and
Ahasuerus
at the Feast
of Esther.*
(Detail).

146

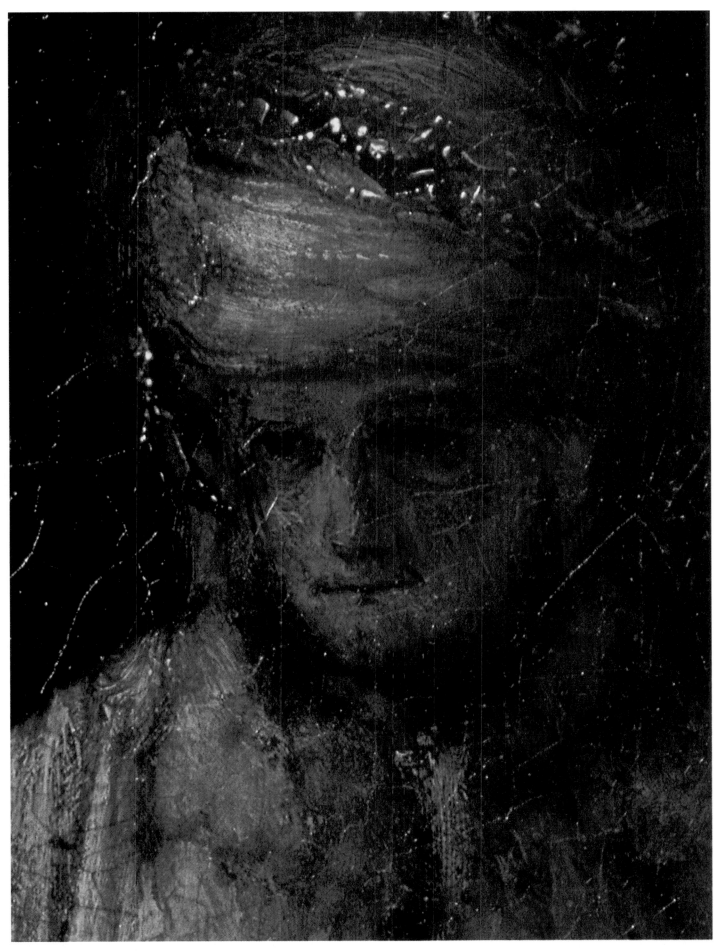

Haman and Ahasuerus at the Feast of Esther. (Detail).

147

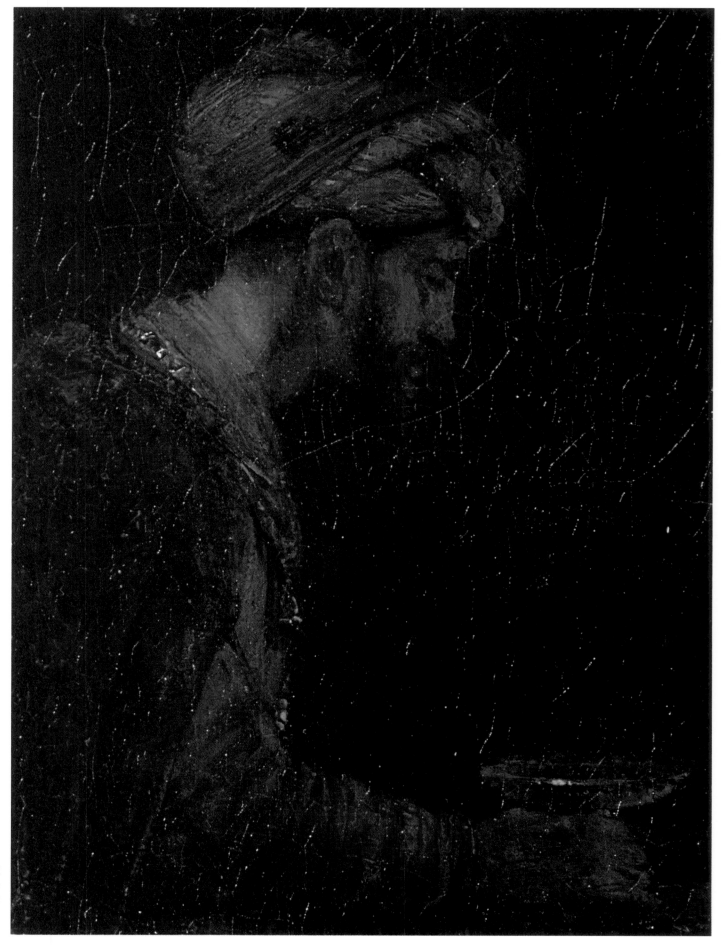

*Haman and
Ahasuerus
at the Feast
of Esther.*
(Detail).

148

Haman and Ahasuerus at the Feast of Esther. Ultraviolet plate.
Pushkin Museum, Moscow.

Haman and Ahasuerus at the Feast of Esther. Infrared plate.
Pushkin Museum, Moscow.

27. THE RETURN
OF THE PRODIGAL SON

Oil on canvas; restretched. 262 x 205 cm.
At the bottom is a fold once used for
shortening the canvas by 10 cm.
On the right, the canvas was enlarged
by a 10 cm wide band.
Originally arched, the top of the painting is
currently straight since the addition of two corners
Signed and dated at the bottom to the left, near
the son's feet: Rv Rynf (the unusual nature of
the signature casts doubt upon its authenticity).
St. Petersburg, Hermitage Museum.
Inv. N° 742. Acquired in 1766.

The story of the prodigal son, simple yet beautiful, is depicted in an expressive yet nonetheless laconical style by the painter, approximately six years before his death: The strict vertical lines of the grave and magnificent figures constitute the composition predominant feature. The father's dress, falling in great folds, and the contours of his face that are continued in his son's, underline the reunion of the two men and impart a monumental character to the group. The figures seem to emerge from the shadows in a flurry of colours. The style particular to Rembrandt's later works acquires in this painting a unique ease which gives birth to a complete freedom of expression.

If the critics unanimously agree that this is one of the artist's great works, the dating of the painting on the other hand arouses some controversy, although the date 1661 seems to be the most plausible due to the quality of the piece. For more than twenty-five years, Rembrandt had in fact been producing drawings and etchings concerned with this particular theme. However, comparing these drawings with the Hermitage Painting one cannot help but conclude that many years of experience lie between them. The painting's format, the ordering of the vertical lines, the solemn silhouettes of the static figures, all differs here from the manner in which Rembrandt broached the theme a quarter of a century earlier. Drawing on the Renaissance engravings, the artist freed himself from this strong pictorial heritage to treat his work as a prayer in which the father, like an officiating priest, conveys in a single gesture forgiveness, mercy and blessing.

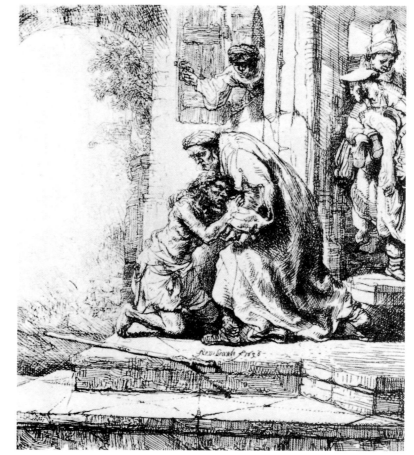

*The Return of
the Prodigal Son.
1636. Etching.*

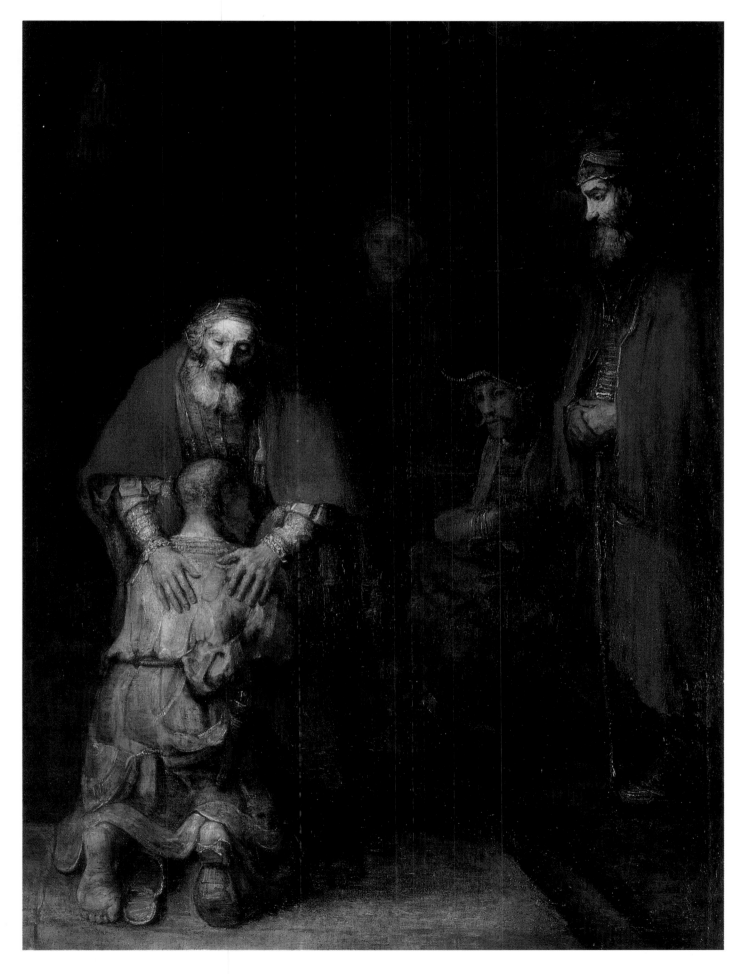

154

*The Return of
the Prodigal Son.*
(Detail).

The Return of
the Prodigal Son.
(Detail).

156

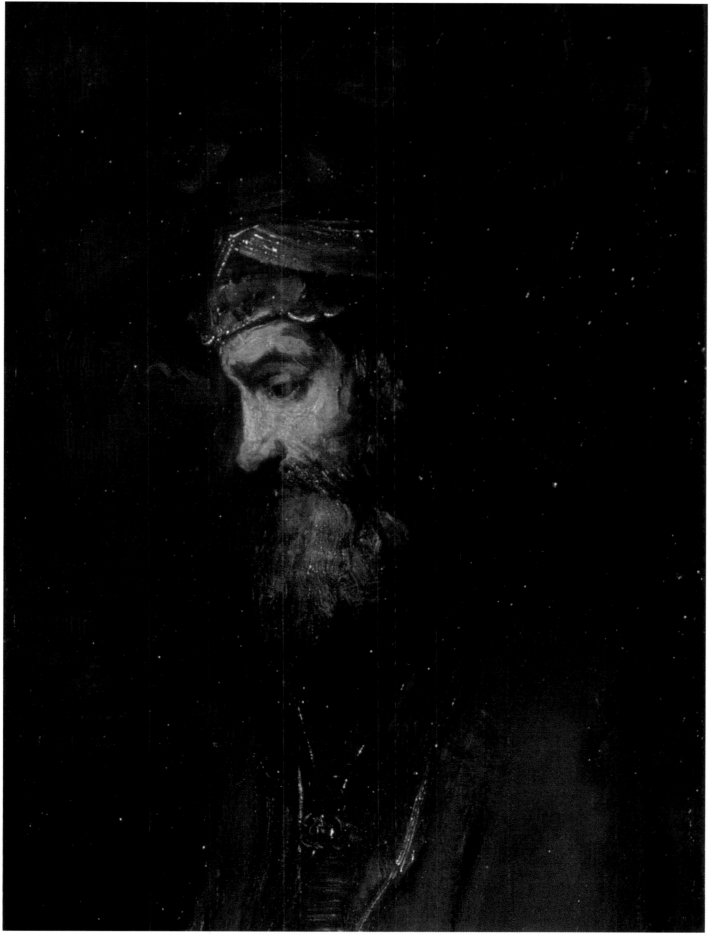

The Return of the Prodigal Son. (Detail).

157

158

*The Return of
the Prodigal Son.*
(Detail).

159

The Return of the Prodigal Son. (Detail).

160

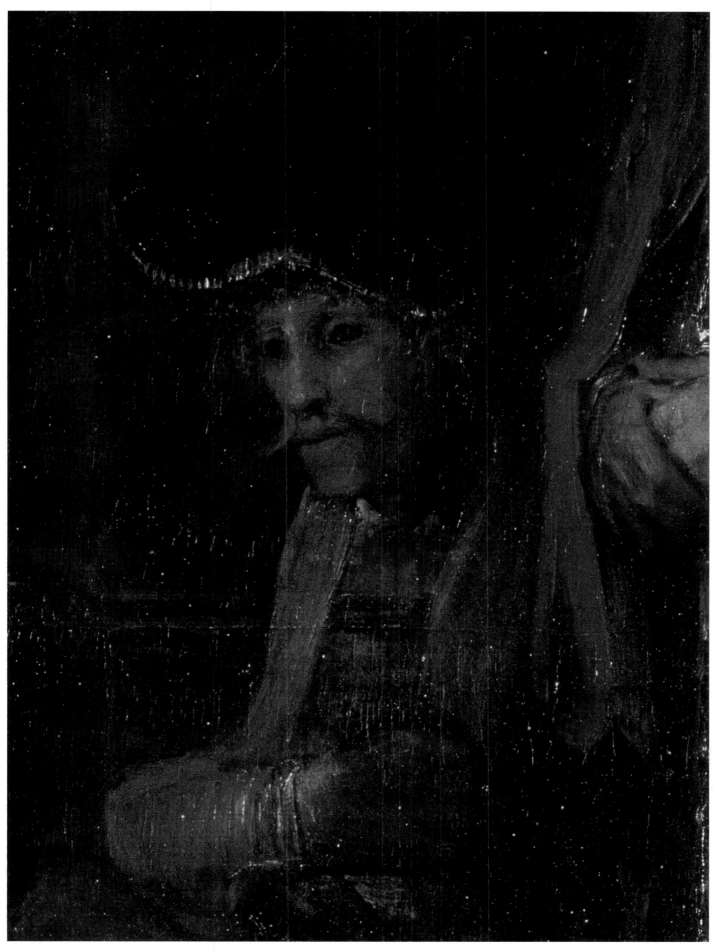

*The Return of
the Prodigal Son.*
(Detail).

162

*The Return of
the Prodigal Son.*
(Detail).

163

28. DAVID AND *ABSALOM* (?)

Oil on canvas; restretched. 127 x 116 cm.
Signed on the right, in the bottom corner:
Rembrandt.
St. Petersburg, Hermitage Museum.
Inv. N° 752. Acquired in 1769.

In the historical paintings Rembrandt created in his final years, he no longer seeks to present a detailed narrative of events. There is therefore a whole series of paintings whose identification gives rise to great difficulties, of which this painting is but one example. When the painting was first exhibited in the Hermitage, and for the following one hundred and fifty years, it was given the title *Haman's Disgrace,* as it was believed at the time that it illustrated chapters IV and VI of the Book of Esther, in spite of the fact that the characters did not correspond to those in the scene described in the Bible. During the 20th century, the Rembrandt specialists world-wide **puzzleded** over this enigma, until in 1956, the painting was given its present title (although not without some hesitation, as some specialists uphold that it is more likely to be Haman receiving the order to honour Mordecai). Seduced by Bathsheba's beauty, General Absalom's wife, King David abused her. Attempting to rid himself of the cuckold husband, the King sent him to his death on the battlefield at the peak of the battle. Suspecting the threat that awaited him, Absalom agreed to go so as not to compromise his honour. More recently, yet another group of critics have placed great importance on the fact that the canvas is incomplete and that in the absence of any elements that could lead to solution to the problem, any attempts to identify it should be abandoned.

The central figure's inner strength and the manner in which the artist has succeeded in conveying his intense and dramatic nature, makes him one of Rembrandt's most powerful creations. His face, drawn an livid, is crushed under his enormous spruce turban. He appears particularly small and pitiful in his sumptuous scarlet costume, where the combination of red and ochre strokes is of an extraordinary chromatic intensity. The figures in the background, smaller than necessary from a perspective standpoint, and their entirely different pictorial quality, lead one to believe that were not Rembrandt's own work.

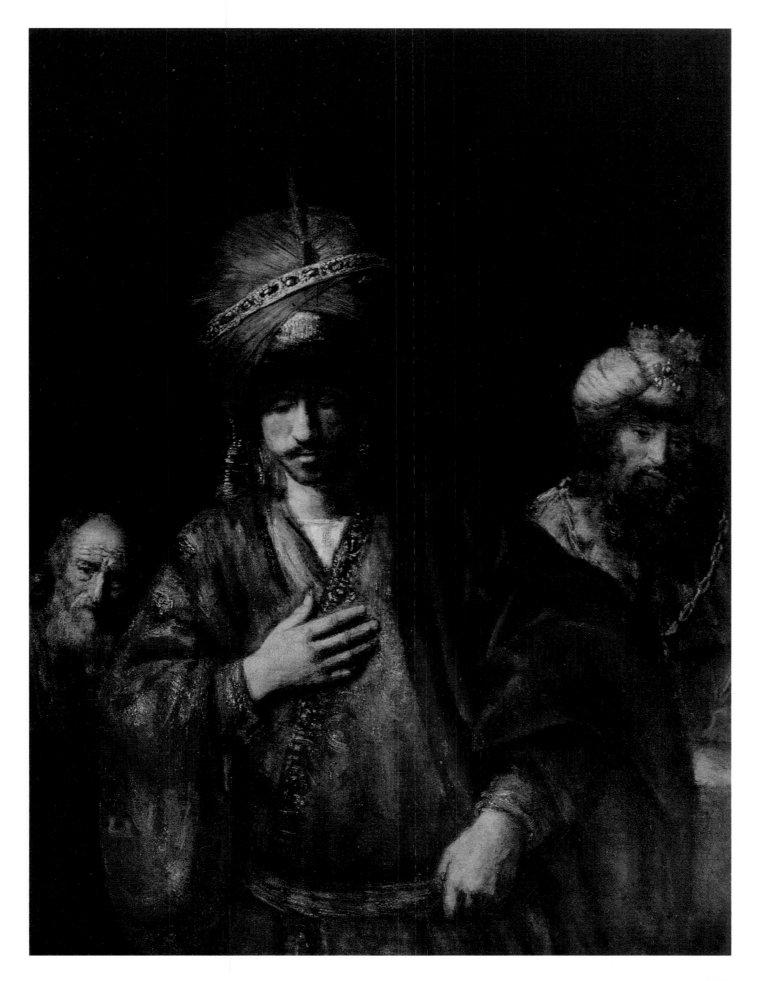

*David
and Uriah (?).*
(Detail).

166

*David
and Uriah (?).*
(Detail).

167

168

*David
and Uriah (?).
(Detail).*

169

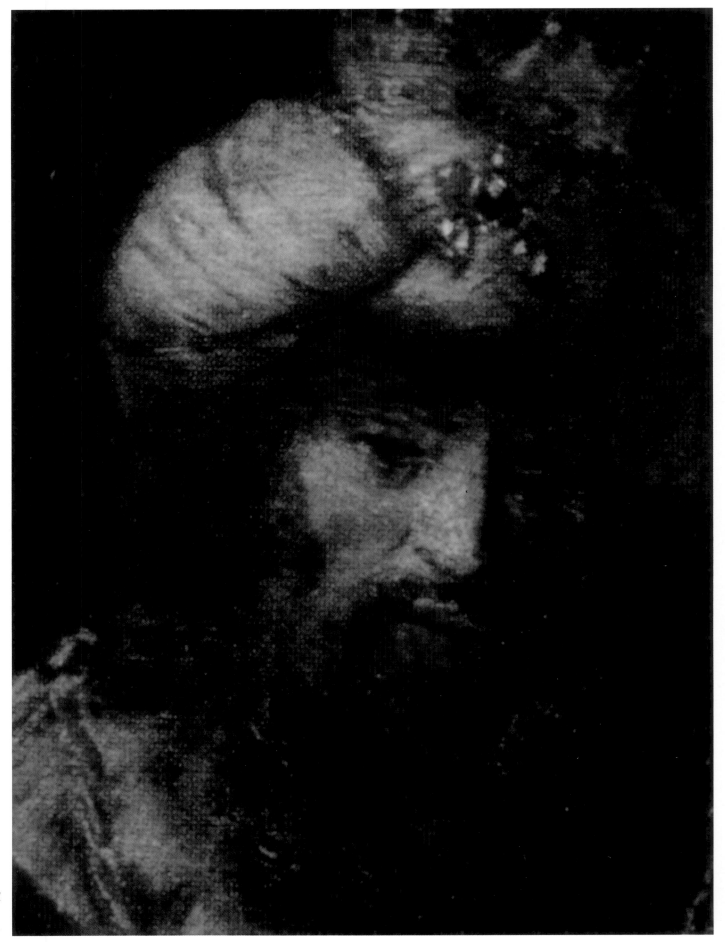

*David
and Uriah (?).*
(Detail).

170

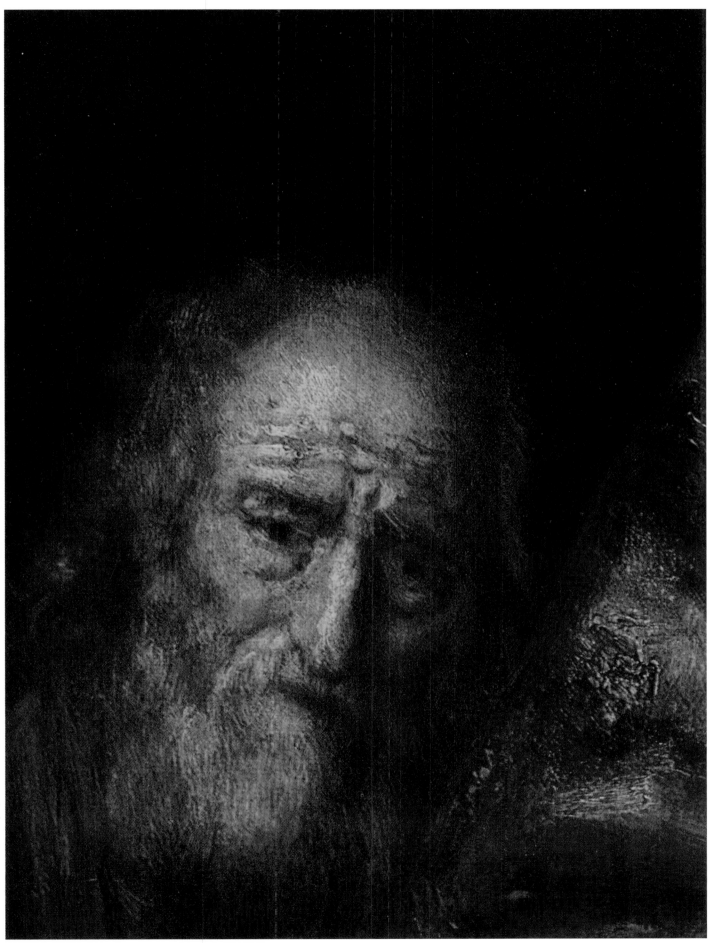

*David
and Uriah (?).*
(Detail).

171

29. THE POET JEREMIAH DE DECKER

Oil on wood (oak); reinforced. 71 x 56 cm.
Signed and dated at the bottom on the right:
Rembrandt. f. 1666.
St. Petersburg, Hermitage Museum.

To understand the interior richness of Rembrandt's art is to enter fully into what was later termed by critics his "tragic expression". Jeremiah de Decker was one of the most talented poets of his century. Rembrandt's contemporary, Jeremiah de Decker was born in Dordrecht in 1606; having lost his parents at a very young age, he lived in hardship until his death which occurred in 1666, the very same year that Rembrandt painted his portrait. "He had few reasons to smile on the world", wrote on Dutch critic quoted by I. Linnik, "and he never smiled. Gravity was his principal character trait. Tenderness, in his constitution, tended to veer to sadness, a deep melancholy that would degenerate into a profound desire to die...". This did not prevent him from being tremendously popular among his contemporaries, who judged him to be amiable, warm and delicate.

For many years the poet was part of the artist's entourage, and in 1638 he wrote of the artist's painting *Christ the Gardener* (London, Buckingham Palace) "Rembrandt my friend, I was the first to witness your masterly strokes as they came to rest on this panel". From the description the poet gives of Rembrandt's chiaroscuro style and his fascination for the richness of the shadows that glide across the scenes depicted, it would seem that Jeremiah de Decker was the first to understand the artist's work.

The Hermitage portrait, which followed from a portrait of the poet completed before 1660, is striking as it is almost completely plunged in shadow; rather than being immediately discernible, the poet's features seem to appear slowly upon close observation, as though one's eyes were accustoming themselves to the darkness.

In fact, Rembrandt seems to have painted this portrait as a homage to a friend who has already left this world; The unfinished state of the work in its lower parts or the bottom of the chest and the hand are barely sketched, gives rise to the possibility that Jeremiah de Decker expired before Rembrandt had completed the portrait.

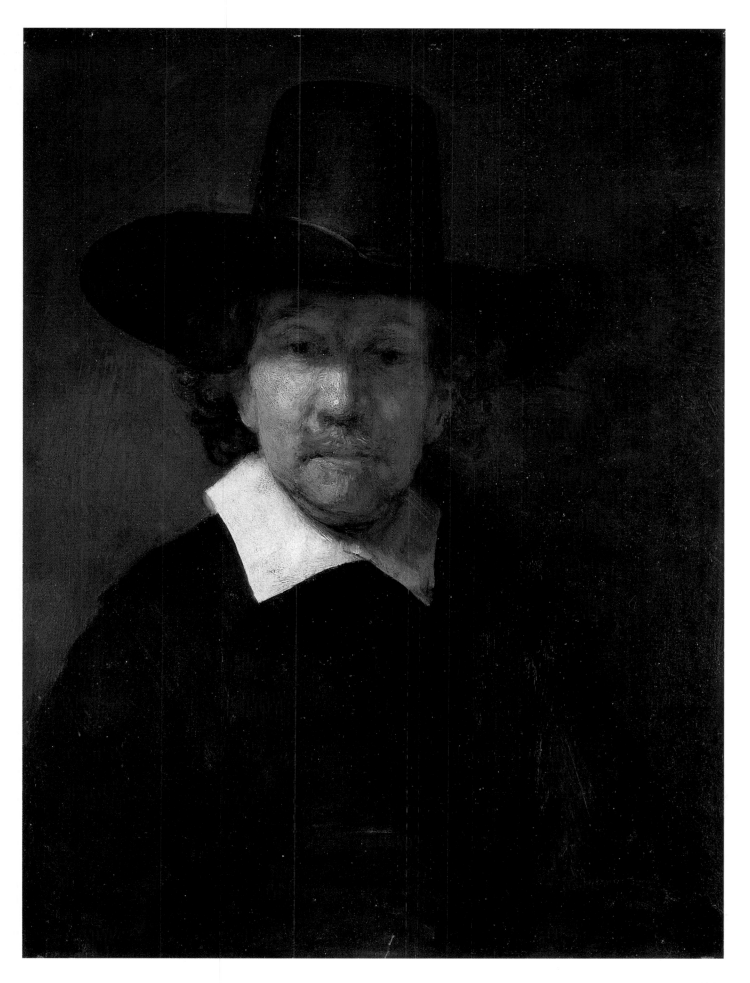

Portrait of the poet Jeremiah de Decker. (Detail).

174

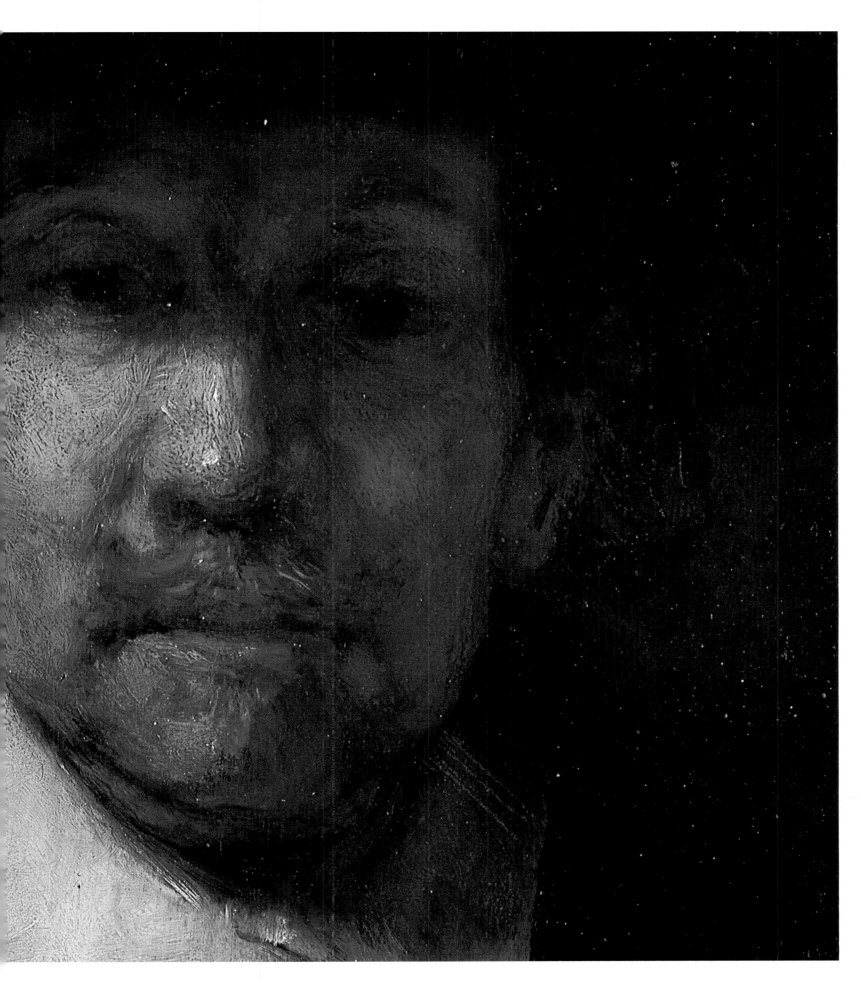